IMAGES
of America

SEATTLE'S
FREMONT

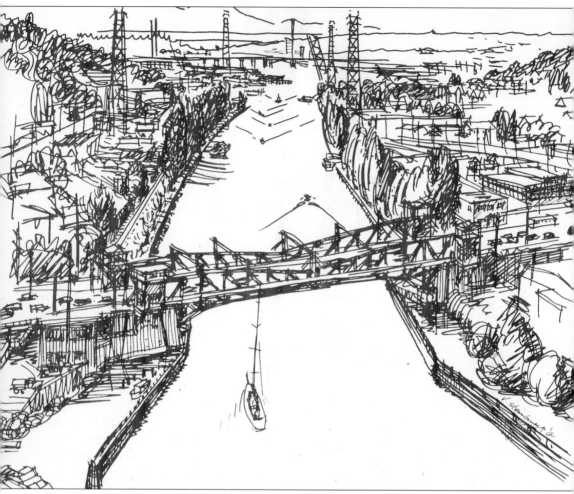

THE FREMONT BRIDGE. Sketched by Seattle artist and historic preservation advocate Victor Steinbrueck (1911–1985), this drawing captures a familiar view of the Fremont Bridge looking west over the Lake Washington Ship Canal. (Courtesy Historic Seattle.)

ON THE COVER: THE FREMONT DRUG COMPANY, C. 1907. Later known as the Fremont Tavern, and now the Red Door, the Fremont Drug Company was located on the northwest corner of Fremont Avenue and Ewing Street (now North Thirty-fifth Street). Built in 1895, it is Fremont's oldest existing building. For more pictures of and history about this building, see pages 17, 91, 92, and 119.

IMAGES
of America

SEATTLE'S
FREMONT

Helen Divjak

ARCADIA
PUBLISHING

Published by Arcadia Publishing
Charleston SC, Chicago IL, Portsmouth NH, San Francisco CA

Printed in the United States of America

Library of Congress Catalog Card Number: 2006920545

For all general information contact Arcadia Publishing at:
Telephone 843-853-2070
Fax 843-853-0044
E-mail sales@arcadiapublishing.com
For customer service and orders:
Toll-Free 1-888-313-2665

Visit us on the Internet at www.arcadiapublishing.com

CONTENTS

ACKNOWLEDGMENTS

First and foremost, I would like to express my deepest thanks to the Fremont Neighborhood Council (FNC), whose funding of this project enabled me to assemble a rich collection of both rare and popular images that best capture the character of our community. Please note that a portion of the sales of the book you now hold in your hands is allotted to the Fremont Neighborhood Council so that they may continue to run programs that benefit and enrich the Fremont community.

I would also like to thank the Fremont Historical Society; in particular, I would like to acknowledge the hard work of Heather McAuliffe, who contributed a wealth of research and images to this book, as well as Judie Clarridge, who provided me with jewels of historical information and personal encouragement. Roger Wheeler, a longtime Fremont resident and local artist, also deserves my most heartfelt thanks. Furthermore, the research and advice of Carol Tobin was critical to my understanding of the development of the Fremont area.

I would also like to express my gratitude to the members of the Fremont Baptist Church and to Anne Johnson of St. John's Lutheran Church, who shared their personal memories and private photograph collections with me. I am appreciative of the support of Fremont Chamber of Commerce board members Suzie Burke (Fremont Dock) and Jeanne Muir (Muir Public Relations), as well as Mike Buchman of the Fremont Public Association and Peter Tomf of the Fremont Arts Council. Fremont photographers John Cornicello (www.johncornicello.com), Mark and Margie Freeman, and Michelle Bates (www.michellebates.net) were exceptionally generous contributors to this work. Credit must be given also to the Museum of History and Industry (MOHAI) and Special Collections at the University of Washington, as well as The History House and The Last Resort, as well as numerous other local and regional archives in the area.

Finally, I would like to thank Julie Pheasant-Albright, my editor and support system throughout the many months that it took to create this work. Her unwavering and affectionate commitment to my work was immeasurable. I also extend my love and gratitude to all of my friends who offered me constant humor throughout the writing of this book. Most importantly, however, I would like to thank my mother and father, who encouraged my love for history from my earliest years. I am grateful to them for giving me the confidence and the tools to pursue my passions.

INTRODUCTION

Western Washington's Puget Sound boasts some of the most spectacular land in the country. From the lush, primeval rain forests of the Olympic Peninsula to the dramatic peaks of the Olympic Mountains and sleeping giant Mount Rainier, it is easy to see how the region's landscape captivated its first white explorers during the 18th century. Given its wealth of natural resources and plentitude of navigable waterways, the eventual migration of white settlers to the area was surely inevitable. In 1851, David T. Denny (1832–1903) became the first member of his family to set foot on the land that would later be named Seattle. Despite the endless days and weeks of rain, not to mention the plethora of other hardships entwined with pioneer life, Denny and his family remained in the Puget Sound region for the rest of their days, staking a claim to the land just south of what was then called by the native Duwamish residents *tenus chuck*, or "little water"—Lake Union. Once the serene home to Puget Sound Salish peoples, the Seattle area was soon infected with the adventurous spirit of pioneers looking for land on which to build a new life.

Over a century later, the appeal that once drew Denny and his contemporaries to the Pacific Northwest continues today, demonstrated by people from all over the United States who flock to the chilly shores of Puget Sound, and Seattle in particular, in order to benefit not only from the area's natural beauty, but also from the unique lifestyle that has become characteristic of the Pacific Northwest. Singular among the places that have defined the ever-appealing flavor of the Greater Seattle region is the neighborhood of Fremont, a district that occupies a central spot within the hills and waterways dividing the Emerald City's eclectic assemblage of neighborhoods.

The self-proclaimed "Center of the Universe," Fremont rests on the northwest shore of Lake Union and the north bank of the Lake Washington Ship Canal. Two hundred years ago, it was little more than a steep, thickly forested hill bordered at its south side by a small, watery ditch. By the late 1880s, however, the area boasted a massive lumber mill that attracted laborers and their families and, at the turning of the 19th century, Fremont, then regarded as a "suburb" of Seattle, had become home to a large number of middle-income families, churches, shops, and other independently owned businesses. Despite its success as a thriving urban enclave in the first half of the 20th century, following the closing of the Bryant Lumber Mill in 1932, Fremont felt the effects of the Great Depression—local commerce, and subsequently the sense of community, began to crumble. Chock-full of vagrants and other "undesirables" who frequented the district's many taverns, Fremont fell out of favor in the 1940s and 1950s. Businesses closed, buildings were abandoned, and houses were left vacant. Although these years were crippling to the neighborhood's sense of identity, not to mention its economy, local students, artists, and intellects in search of affordable housing were able to take advantage of Fremont's downturn and transform the area into a low-income bohemian haven. By the late 1970s, Fremont's artistic rebirth, for which it is still known today, had begun.

In recent years, the Fremont neighborhood, despite controversial development and gentrification, has gained fame for its "quirky" personality that draws visitors far and wide, and is marked by its unusual pieces of public art, as well as by local seasonal celebrations such as the annual Solstice

Parade and "Trolloween." Still home to "starving" students and artists, as well as to a new contingent of well-to-do professionals and families, Fremont now thrives with many of the city's favorite bars and restaurants, as well as with a multitude of boutiques and art galleries that cater to the worldly aware. Recently made the headquarters of high-tech giants like Adobe Systems Incorporated and Getty Images, Fremont continues to evolve, reflecting the changes in industry that have contributed to Seattle's reputation as an urban area on the cutting edge.

In order to reflect the stages of Fremont's past, *Seattle's Fremont* is organized into three chapters. The first chapter, "Bridging Fremont: the Construction of a Community," discusses Fremont's earliest days, as well as the industries, infrastructure, and individuals that have enabled the area to become an established and unique entity within Seattle's urban landscape. Chapter 2, "Fremont's Faces: The Neighborhood Grows," concentrates on the neighborhood's young but burgeoning community by featuring the residents and institutions that have contributed to Fremont's unique character. Finally, Chapter 3, "Fremont's Revival: the Birth of an ImagiNation," is an exploration of the manner in which Fremont has defined itself in recent decades as one of the Emerald City's most desirable and unusual places to experience daily life.

It is my sincere hope that this volume will provide readers with an introduction to the fertile history that has marked Fremont's physical and social landscape. For although growth and development have introduced a plethora of opportunity to Fremont, members of this community continue to take to a great deal of pride in its historic legacy. For this reason, *Seattle's Fremont* is not intended be a definitive or comprehensive history of the Fremont district but rather is intended to encourage the area's residents and visitors to ask questions about the neighborhood's heritage, as well as promote further research and investigation of the stories that have enriched our community. Should you discover that you have your own collection of memories and/or photographs that capture Fremont's past and have not been included herein, please contact the Fremont Historical Society for information on how you can share them with the public.

One

BRIDGING FREMONT
THE CONSTRUCTION OF
A COMMUNITY

Named after the hometown of its Nebraska-native founding fathers, Edward Blewett and Luther H. Griffith, Seattle's Fremont was first established in 1888 when King County granted Blewett permission to plat the area then referred to as Denny and Hoyt's Addition. Prior to Blewett's acquisition of the land, much of the area that would be Fremont had belonged to homesteader William A. Strickler. Upon his death in 1872, however, this land was sold in order to cover Strickler's tax debts. Pioneer John Ross and Henry Yessler of Lake Washington Improvement Company had also owned land here, but it was not until Blewett and Griffith decided to invest in this suburb north of Seattle, with the help of a Dr. Edward C. Kilbourne, that the area was formally named and recognized. In little time, Fremont's popularity increased among businessmen and family men alike, and by the time the area was annexed by Seattle in 1891, Fremont's population had already reached 5,000 people.

The following chapter explores the early days of Fremont, focusing particularly on the manner in which this untouched natural landscape transformed rapidly into an urbanized extension of Seattle's downtown. From the deforestation that allowed Fremont residents to creep uphill and away from the district's loud and polluting mill, to the massive effort of digging a canal that would connect Lake Washington to Puget Sound, the next few pages illustrate the manner in which early Fremont residents tamed the land for their benefit. Not to be forgotten, of course, are Fremont's bridges. Both pragmatic and iconic, the Fremont Bridge and George Washington Memorial (Aurora) Bridge act as marks on a time line of Fremont history that signal the major eras of the neighborhood's history.

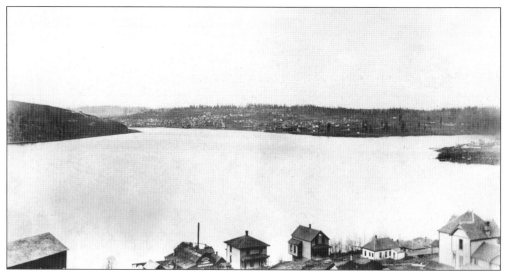

LOOKING WEST ACROSS LAKE UNION TOWARD FREMONT, C. 1893. Taken from Capitol Hill, this photograph looking over Lake Union captures an early view of the Fremont neighborhood. At a picnic on July 4, 1894, Lake Union received its name from Seattle founding father Thomas Mercer, in anticipation of its role in connecting Puget Sound with Lake Washington. The lake proved itself to be integral to many of Fremont's earliest industries, especially lumber milling. When this picture was taken, *tenus chuck*, or "little water" as the Lake Union was then known to native Salish peoples, was one third bigger—by about 300 acres—than it is today. (Courtesy University of Washington Libraries, Special Collections, UW4465.)

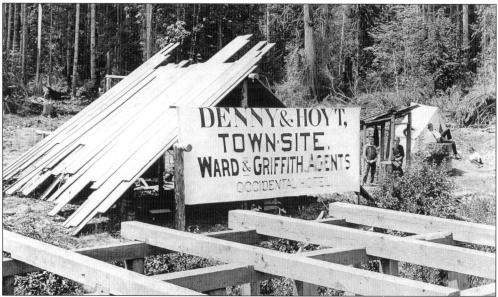

FREMONT'S "FIRST" BUILDING, MAY 1888. On May 8, 1888, King County approved Edward Blewett's platting of the Denny-Hoyt Addition, an area occupying land close to Lake Union's north shore and the lower portion of Fremont's hill. Having acquired the land from David Denney and Judge John P. Hoyt, Blewett, together with Luther H. Griffith and E. C. Kilbourne, were the major players in Fremont's early development. (Courtesy University of Washington Libraries, Special Collections, UW6917.)

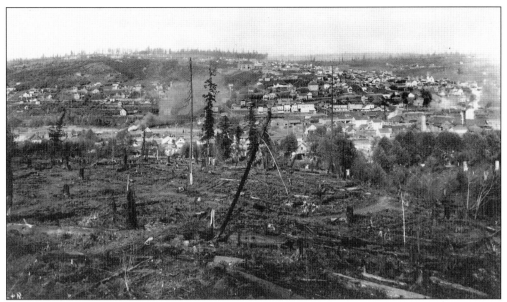

VIEW OF FREMONT FROM QUEEN ANNE HILL. It took little time for Seattle's early settlers to take advantage of the rich natural resources that the Puget Sound area boasted. In this photograph, probably taken in the 1890s, both Queen Anne Hill and Fremont have been almost entirely cleared of their natural landscapes. The strong, old-growth lumber missing from this image was ideal for building both within and outside the immediate urban area. (Courtesy University of Washington Libraries, Special Collections, A. Curtis 00673.)

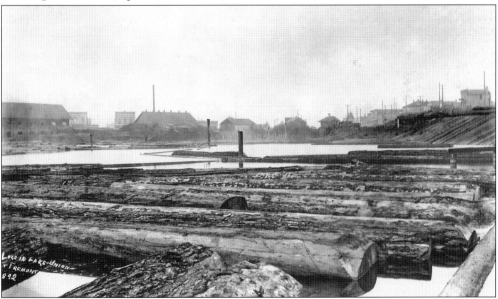

FREMONT MILLING COMPANY, C. 1892. In 1888, Isaac Burlingame moved his sawmill from Tumwater to Fremont where he could take advantage of Lake Union's waterfront and nearby logging. This view of Burlingame's mill shows the manner in which logs lined the lake's shores waiting to be processed. In 1896, the Bryant Lumber and Shingle Mill, founded in 1890, took over the Fremont Lumber Mill and continued to operate there until 1932, when it was destroyed by a fire. (Courtesy University of Washington Libraries, Special Collections, UW4412.)

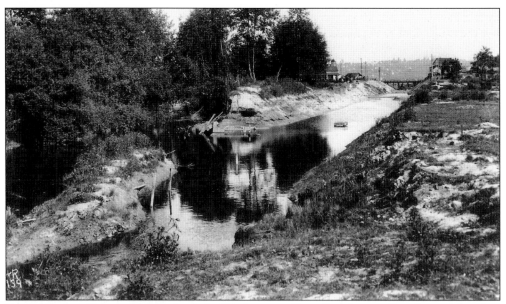

EARLY CANAL BANKS. Before the Lake Washington Ship Canal was officially completed in 1917, Fremont was separated from Queen Anne at its south end by little more than a watery ditch. Seattle's first white settlers, however, recognized the potential in using this strip of land to connect Lake Washington to Puget Sound via Lake Union. This picture, looking east across Fremont toward Capitol Hill, demonstrates early efforts to create a larger waterway. (Courtesy University of Washington Libraries, Special Collections, A. Curtis 01739.)

JUDGE THOMAS BURKE. Thomas Burke, along with his partner, Daniel H. Gilman, made considerable contributions to the development of Fremont when, during the 1880s, both men invested in the Lake Shore and Eastern Railway, which traveled along Lake Union's north shore and what was later the north banks of the ship canal, thereby also encouraging development along the train's route. Today bicyclists, runners, and walkers continue to follow the path that the train took through Fremont on its way toward Ballard on the Burke-Gilman Trail. (Courtesy MOHAI, 12454.)

LEILLA SHOREY KILBOURNE. Leilla Shorey was the daughter of early pioneers and the wife of Edward Corliss Kilbourne (1856–1959), one of the critical early investors and developers of the Fremont neighborhood. In addition to being an accomplished dentist, E. C. Kilbourne can also be given credit for introducing a number of public transport systems, which connected Fremont with downtown Seattle, including the *Maud Foster* ferry service across Lake Union and, with the help of business partner Luther H. Griffith, the city's first electric streetcars. Having grown up in Aurora, Illinois, Kilbourne named Aurora Avenue in remembrance of his hometown. (Courtesy MOHAI, 2641.)

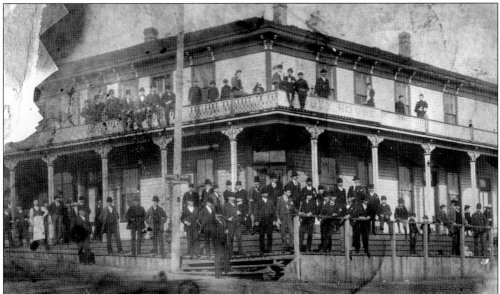

SHOREY HOUSE, THIRTY-FOURTH STREET NORTH AND FREMONT AVENUE, C. 1890. The Shorey House, built in 1888 by W. A. Shorey and located just north of Fremont's lumber mill, functioned as a boardinghouse and leisure spot for the mill's workers. (Courtesy University of Washington Libraries, Special Collections, UW4415.)

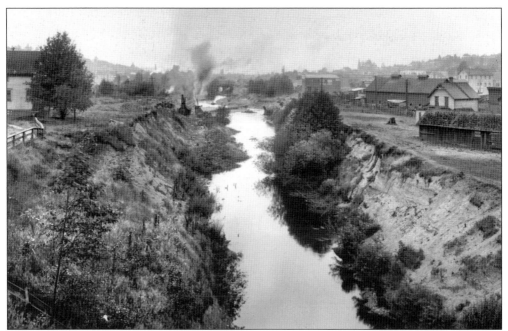

EARLY DAYS OF THE CANAL. Looking west across Fremont toward Ballard, this image shows the rapid speed at which people relocated to Fremont. Houses, as well as industrial and commercial buildings, quickly popped up along the young shores of what would become the Lake Washington Ship Canal. (Courtesy MOHAI, 83.10.6931.)

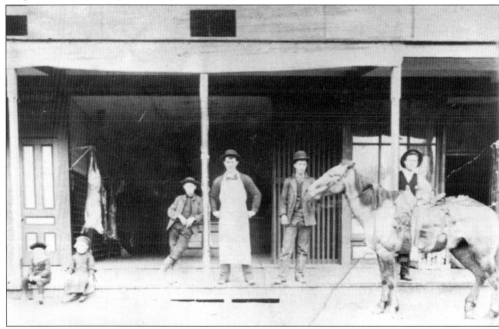

BUTCHER SHOP. With an increasing population, there came a need for commercial enterprise in Fremont that would provide for the area's residents. This rare, faded photograph documents one of Fremont's first shops. (Courtesy University of Washington Libraries, Special Collections, UW4469.)

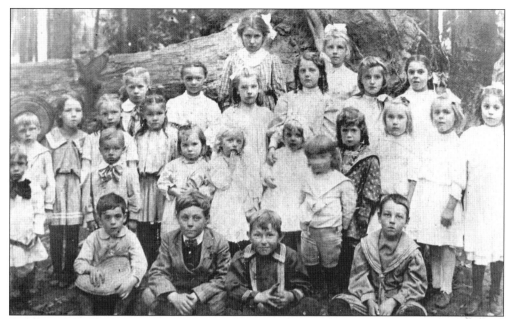

FREMONT'S FIRST CHILDREN. While the area had initially been home primarily to young men seeking work in the mill, Fremont soon attracted families as well. It is estimated that 147 youngsters between the ages of 5 and 21 lived in Fremont in 1889. This number jumped to 248 the following year. In the background, the large, toppled tree stump is a reminder of the wilderness that still embraced the area. (Courtesy Fremont Baptist Church.)

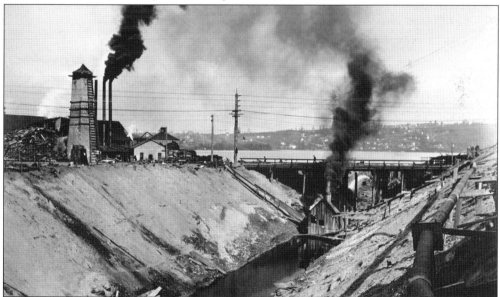

BRYANT LUMBER MILL. Other than deforestation, perhaps the single greatest alteration of the Fremont area's natural landscape was the creation of a canal to connect Puget Sound with Lake Washington via Lake Union. This photograph, looking east, shows early efforts to cut the canal. Note Bryant Lumber Mill's tall cylindrical tower that stands upon the left bank. This tower offers a point of reference for many pictures throughout this book. (Courtesy Army Corps of Engineers.)

WOODEN TRESTLE RAILROAD ALONG WESTLAKE, 1893. As Fremont grew and industrialized, transportation for its goods, as well as its workers and residents, was essential. The wooden railroad trestle that follows the western shores of Lake Union toward Fremont is pictured above. (Courtesy University of Washington Libraries, Special Collections, UW4411.)

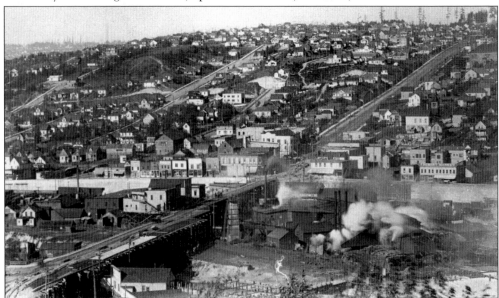

UPHILL CRAWL. While the Bryant Lumber Mill provided plenty of jobs and helped to fuel the local economy, it was also a massive air and water polluter, as is illustrated here by the steam and smoke pluming from its buildings. Residents often found it more desirable to relocate further up Fremont's hill in order to escape from the smell. Thus residential development slowly crawled up and away from the waterfront. (Courtesy University of Washington Libraries, Special Collections, Hamilton 3959.)

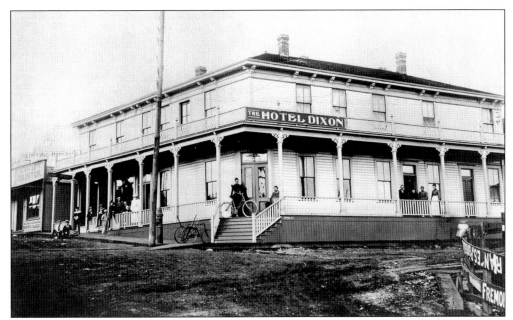

THE HOTEL DIXON. Like its predecessor, the Shorey House, the Hotel Dixon also provided mill workers with a place to sleep and eat. Entering Fremont across the rickety trestle bridge that spanned the mill's dam, Hotel Dixon would have been one of the first buildings at the northeast corner of Fremont Avenue and Thirty-fourth (then called Ewing) Street. (Courtesy University of Washington Libraries, Special Collections, Hamilton 1223.)

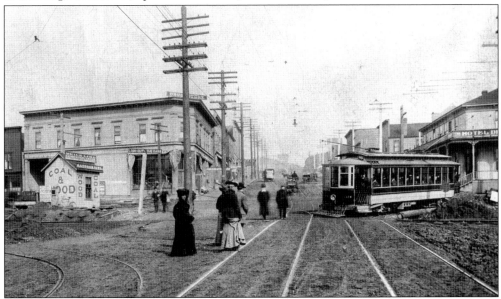

INTERSECTION AT FREMONT AVENUE AND THIRTY-FOURTH STREET. The introduction of electricity to Seattle revolutionized the speed and manner in which people could move away from the city's urban core. In this photograph, the impact of electricity is marked not only by the presence of a streetcar, but also by the looming electric wire towers lining Fremont Avenue's west side. Note Hotel Dixon to the left and, across the street, Fremont Drug (see cover image). (Courtesy MOHAI, 10729.)

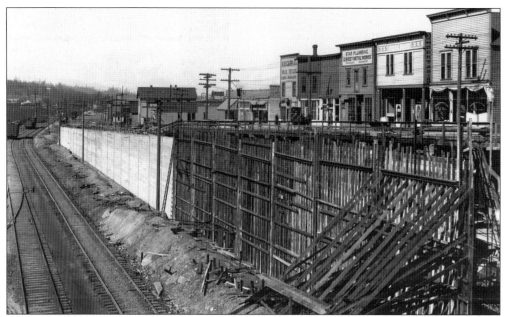

RETAINING WALL ALONG THIRTY-FOURTH STREET. Stretching across Thirty-fourth Street from Stone Way all the way to Phinney Avenue, this wall still stands today. Initially the wall served as a barrier separating the Bryant Lumber Mill and Burke and Gilman's busy railroad (see page 12) from the area's commercial and residential areas. It also marks the steep grade difference from Fremont's waterfront to its commercial center. (Courtesy MOHAI, 83.10.9152.)

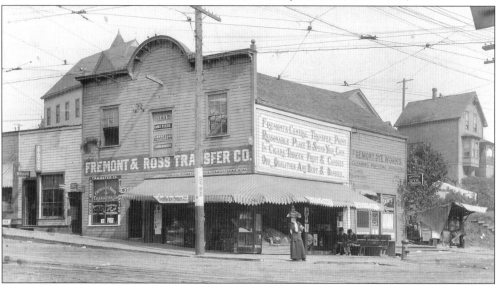

FREMONT AND ROSS TRANSFER COMPANY In less than 20 years, Fremont was transformed from a wooded wilderness into an respectable and fully modernized Seattle suburb, serviced by a number of owner-operated shops, as well as by a reliable streetcar system that connected Fremonters to Seattle's downtown. The billboard on the side of this building reads, "Fremont's Central Transfer Point/Reasonable Place to Spend Your Coin/In Cigars, Tobacco, Fruit and Candies/Our Qualities Are Best and Dandies." (Courtesy University of Washington Libraries, Special Collections, Lee 391.)

18

EMMA M. GODDARD. In addition to its first businesses, Fremont's early growth was also a result of the personalities who filled the neighborhood's houses and streets. Pictured here is early Fremont resident, Emma M. Goddard, the first woman to acquire a steamship license on the Yukon River in Alaska. (Courtesy MOHAI, 6108.)

CAPT. ALBERT GODDARD. Husband to Emma M. Goddard, Fremont resident Albert Goddard was well known for his exploits on the Yukon River during the Alaska gold rush of the late 19th century. In 1888, his mother, Agnes Goddard, was responsible for opening Fremont's second school, after the Ross School, which operated out of her own home. (Courtesy MOHAI, SHS 6264.)

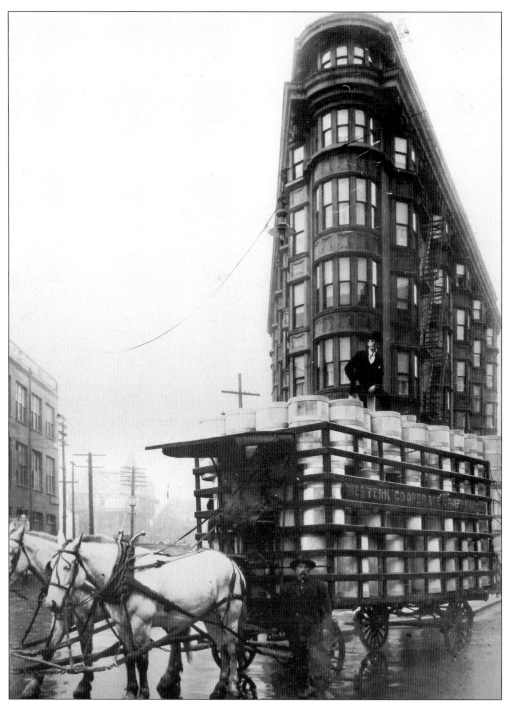

WESTERN COOPERAGE MAKING A DOWNTOWN DELIVERY. Western Cooperage Company was among the first businesses to settle along Fremont's waterfront, just east of the lumber mill. It was also one of Fremont's most long-lived businesses, providing "Barrels, Kegs, Casks, Tanks, Coffee Drums, and Bar Novelties." (Courtesy Fremont Baptist Church.)

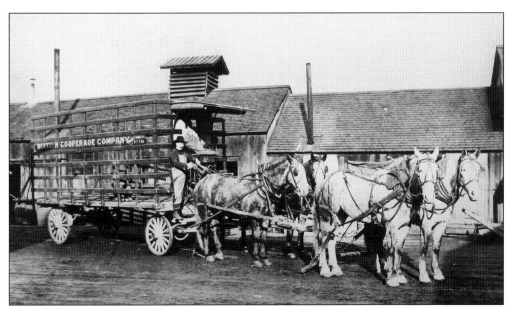

WESTERN COOPERAGE AT HOME IN FREMONT. Those paying attention to the details might claim that Western Cooperage was technically located in Edgewater, a small district nestled at the base of Stone Way between Fremont and Wallingford, its neighbor to the east. Nonetheless, its presence upon the north shore of Lake Washington allowed it to be a prominent Fremont fixture. (Courtesy Fremont Baptist Church.)

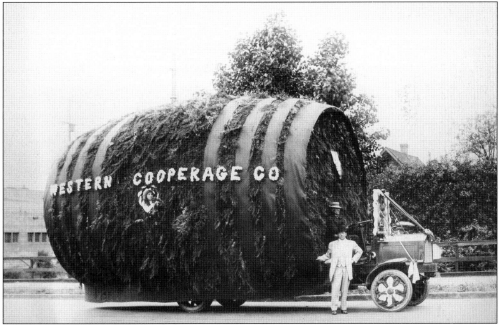

WESTERN COOPERAGE PREPARING FOR A PARADE. This bizarre and rather humorous photograph taken in the early 1900s shows a blank-faced young woman peeking out from a hole in an oversized barrel. During this time, parades were not only celebrations used to bring a city together, but also a terrific opportunity to advertise local businesses. Other early Fremont industries included iron works, machine works, and tanneries, as well as retailers. (Courtesy Fremont Baptist Church.)

SEATTLE ELECTRIC'S FREMONT SUBSTATION. Although this picture was snapped in the late 1930s, it is indicative of the impact that electricity had on the development and expansion of Seattle at its northern borders in the early 1900s. Tucked behind the corrugated metal barn at the forefront of the photograph is a white, towered building that was built in 1902 by Seattle Electric, a subsidiary of Stone and Webster. One of the first substations built in Seattle, this structure provided the electricity that allowed development north of Seattle to Greenlake, as well as powered the streetcars that operated through Fremont to Ballard, Wallingford, Phinney Ridge, and the Ravenna/Brooklyn (University District) neighborhoods. In 2006, despite the efforts of a group of local residents who sought to preserve the building as a testament to pioneering electrical technology, the substation was scheduled for demolition. (Courtesy Seattle Municipal Archives.)

LOOKING NORTH ACROSS THE FREMONT TRESTLE BRIDGE, MARCH 18, 1915. Before today's Fremont Bridge was built, a handful of small trestle bridges spanned the entrance to Fremont from its south side. This photograph was taken shortly before the trestle bridge shown was torn down to make way for the construction of the Lake Washington Ship Canal. Notable are not only the train tracks at the lower right edge of the image, but also the streetcar tracks to the left of the image. Bryant Lumber Mill's tower (see page 15) can also be spotted, as well as B. F. Day School (see pages 71–76), perched atop the hill. (Courtesy Seattle Municipal Archives.)

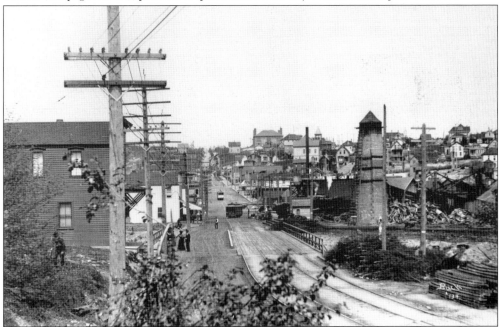

FREMONT'S EARLY BRIDGE. This view of Fremont looking north up Fremont Avenue provides another look at the wooden trestle bridge over which streetcars, carriages, and pedestrians crossed each day, before the completion of the current steel bascule bridge. Again, note the Bryant Lumber Mill's large stone tower, as well as the B. F. Day School on the hill. (Courtesy MOHAI, 9838.)

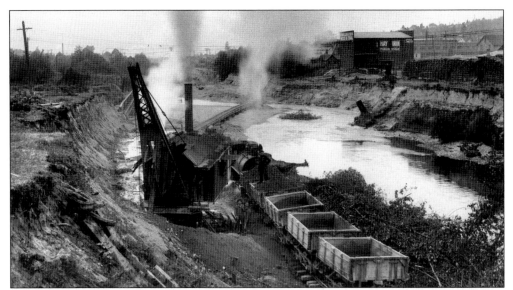

DIGGING THE SHIP CANAL. Since the 1860s, Seattle's settlers envisioned cutting a waterway from Salmon Bay to Lake Union and on to Lake Washington. Without a doubt, the digging of the Lake Washington Ship Canal was one of the largest engineering ventures to affect the face of Fremont, as well as the rest of the Puget Sound region. Official construction of the canal began in 1911 under the leadership of Hiram M. Chittenden (1858–1917), a general in the Army Corps of Engineers. The canal was opened to traffic in 1917, although it was not officially completed until 1934. (Courtesy MOHAI, 83.10.6934.)

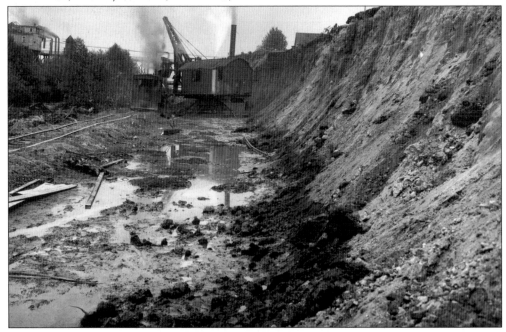

MUDDY WATERS. This photograph shows another view of the monumental task of removing tons of damp soil to make way for the Lake Washington Ship Canal. It is estimated that the costs of the canal amounted to $3,345,500 for the federal government, $246,187 for the State of Washington, and $142,000.50 for King County. (Courtesy MOHAI, 83.10.69.32.)

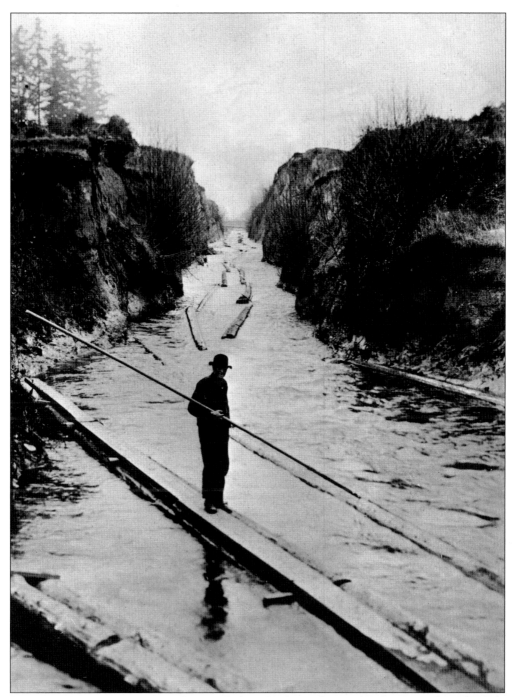

FLOATING LUMBER DOWN THE CANAL. Before the Army Corps of Engineers took to the task, previous independent efforts to dig the canal had produced enough of a waterway to allow smaller vessels and logs to travel from Salmon Bay to Lake Union before the close of the 19th century. By the late 1880s, for example, Wa Chong and Company, a local Chinese contractor, had dug enough of a ditch to allow lumber to float from the Ballard sawmills east to Fremont. (Courtesy Army Corps of Engineers.)

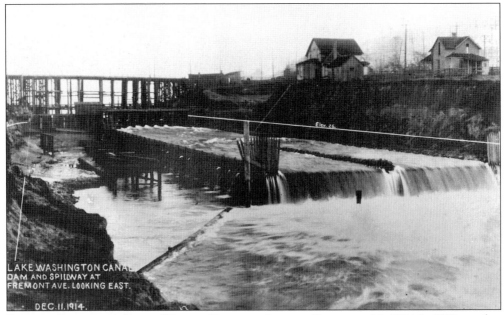

SPILLWAY FILLING THE CANAL WEST OF FREMONT AVENUE, DECEMBER 11, 1914. In 1912, another temporary trestle bridge was built at the south end of Fremont Avenue to span the increasingly large cut of the canal and to replace the bridge that was torn down in 1911. Also constructed was this wooden spillway that allowed water to flow from Lake Union into the canal. (Courtesy University of Washington Libraries, Special Collections, Hamilton 2110.)

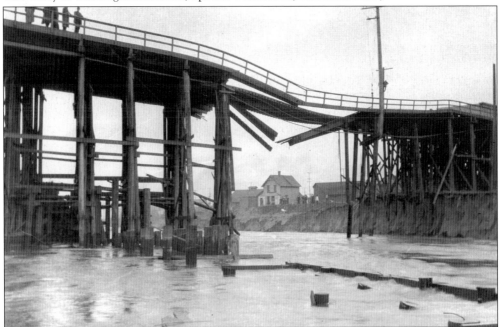

DAMAGED FREMONT BRIDGE. In 1914, a temporary construction dam burst causing Lake Union to drop by 10 feet in just 24 hours, causing this damage to the temporary Fremont trestle bridge. Construction of a sturdier, more permanent Fremont bridge would not begin until 1915. (Courtesy History House.)

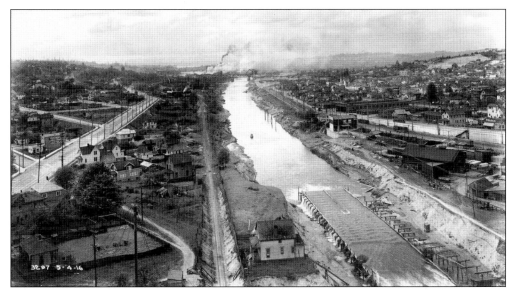

CANAL CONSTRUCTION CONTINUES, MAY 4, 1916. This view of the Lake Washington Ship Canal looking west toward Ballard helps to show the scale of the project begun in 1911. As mills along the western skyline fill the air with smoke plumes, water spills from Lake Union into the canal along the spillway. (Courtesy MOHAI, 2006.7.1.)

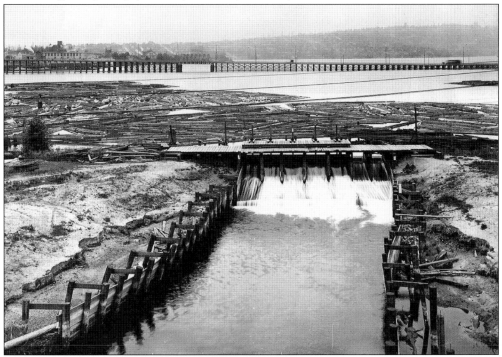

THE BRYANT LUMBER MILL'S DAM AT LAKE UNION, C. 1917. This image demonstrates the manner in which lumber clogged Lake Union's northwest banks at the Bryant Lumber Mill. In the distance, note the Stone Way Bridge that served as the major north-south causeway over Lake Union while the canal was under construction. In 1917, this bridge was taken down in favor of the brand new Fremont bascule bridge. (Courtesy Mark Freeman.)

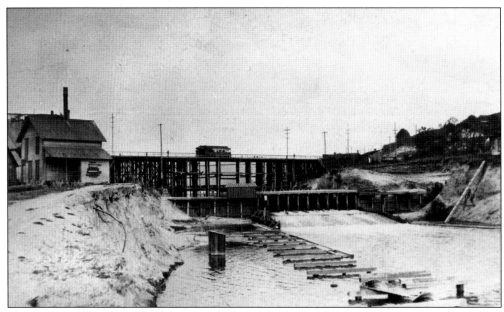

THE RICKETY FREMONT TRESTLE BRIDGE. By 1915, the need for a sturdy bridge that would allow the passage of large ships in and out of the canal at Fremont Avenue was undeniable. This trestle bridge, which carried both streetcars and pedestrians, had met the end of its days. (Courtesy University of Washington Libraries, Special Collections, UW1491.)

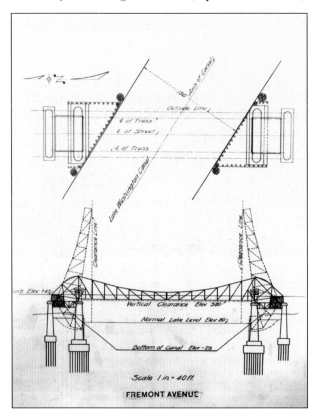

PLANS FOR THE FREMONT BRIDGE. In the summer of 1915, contracts for building a bascule (the French term for balance) bridge in Fremont were awarded to U.S. Steel and Pacific States Construction Company. Based on similar bridges that stretched over Chicago's waterways, the Fremont Bridge's steel structure was designed F. A. Rapp, while the concrete bases were designed by architect D. H. Huntington. (Courtesy Seattle Municipal Archives.)

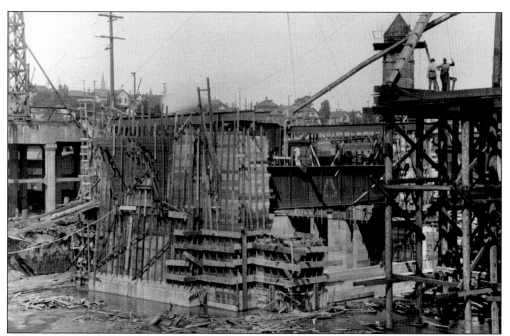

CONSTRUCTION BEGINS ON THE FREMONT BRIDGE. Almost immediately after contracts for the project were awarded, construction on this Fremont icon began. This photograph, taken on July 7, 1916, demonstrates how wooden scaffolding and large steel beams were used to build the bridge's huge concrete bases. (Courtesy Seattle Municipal Archives.)

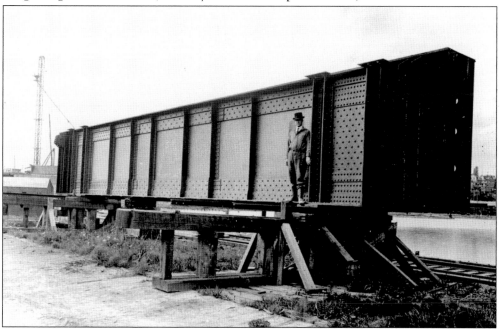

STEEL BEAM USED IN CONSTRUCTION, FREMONT BRIDGE. Unless personally familiar with the Fremont Bridge, its scale might be hard to imagine for some. Here a laborer stands next to one of the steel beams used in the bridge's base. A similar steel beam can be spotted in the photograph above. (Courtesy Seattle Municipal Archives.)

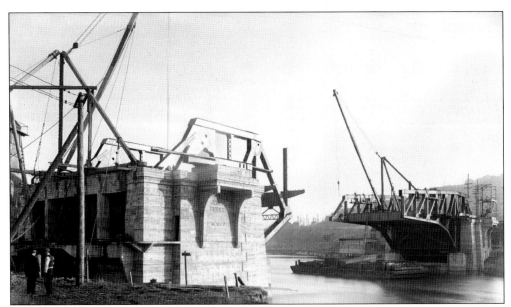

BRIDGE CONSTRUCTION CONTINUES, NOVEMBER 16, 1916. The winter afternoon sun shines from the west on the unfinished Fremont Bridge. Reaching across approximately 250 feet of water, the steel leaves of the bridge stand only 30 feet above water level and are moved by 780 tons of counterweight. Prominent upon both concrete bases, the inscription reads "Fremont Bridge MCMXVI," marking 1916 as the year of the bridge's construction. (Courtesy Seattle Municipal Archives.)

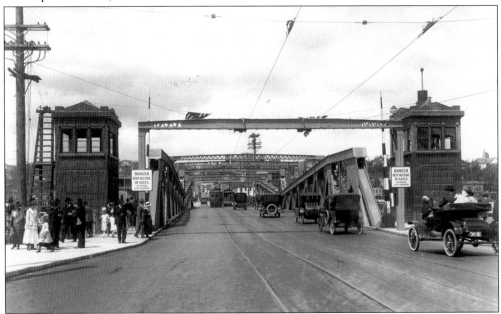

OPENING DAY OF THE LAKE WASHINGTON SHIP CANAL, FREMONT BRIDGE, 1917. Just after midnight on June 15, 1917, the Fremont Bridge was officially opened to traffic. Three weeks later, on July 4, the Lake Washington Ship Canal was formally opened. This picture, taken on the opening day of the canal, shows how people flooded the bridge's sidewalks, automobiles took to its streets, and streetcars slid across new steel tracks. (Courtesy MOHAI, 83.10.10565.)

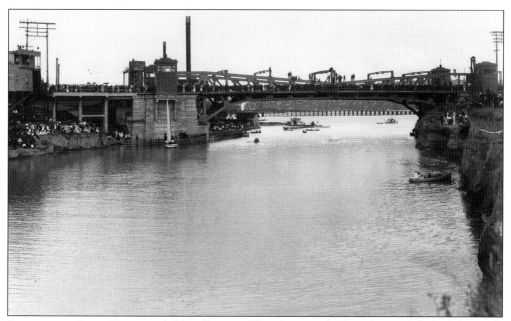

SEATTLEITES ENJOY FREMONT'S NEW BRIDGE. This photograph, also taken on July 4, 1917, reveals the excitement that was felt among locals at the opening of Seattle's grand canal system and new bridges. Note how crowds have swarmed over the bridge, as well as cover the canal's north and south banks. Beneath the bridge in the distance, one can just make out the temporary Stone Way Bridge that was torn down that same year. (Courtesy MOHAI, 83.10.10565.)

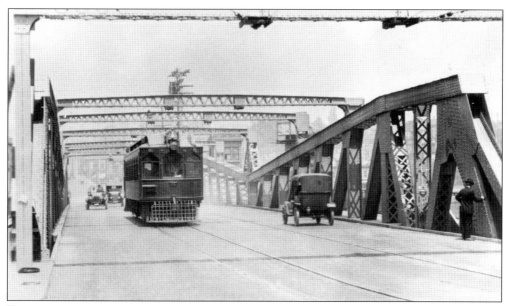

TRAFFIC OVER FREMONT BRIDGE. Not long after the Fremont Bridge opened, it quickly became one of the busiest bridges in the city. Connecting north Seattle with downtown, hundreds of electric streetcars, trucks, and automobiles passed over it each day. By 1930, 35,000 vehicles were estimated to use the bridge daily. (Courtesy University of Washington Libraries, Special Collections, Hamilton 1492.)

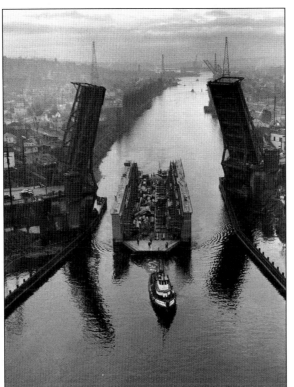

THE FREMONT BRIDGE IN SALUTE. Watching the Fremont Bridge in action is as much a spectacle today as it was in 1916. In less than 10 minutes, the bridge can clear itself of traffic, raise its steel trunnions to allow ships to pass through, and return itself to position. Because it stands only 30 feet above the water's level and is constantly having to open and close to allow boats to pass beneath its steel arms, the Fremont Bridge is recognized as one of the busiest drawbridges in the world. (Courtesy MOHAI, 86.5 9762.2.)

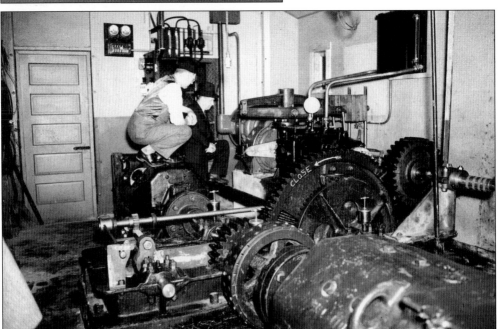

MACHINE ROOM, FREMONT BRIDGE. This photograph reveals the rarely seen interior of the Fremont Bridge and the massive machines that are responsible for raising the bridge dozens of times per day. The original 100-horsepower engine has changed little since it was first used nearly a century ago. (Courtesy Seattle Municipal Archives.)

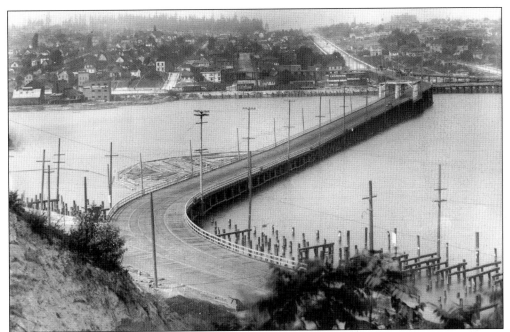

LOOKING NORTH AT STONE WAY BRIDGE. Before the completion of the Fremont Bridge, this temporary bridge built in 1911 connected Westlake to Stone Way at Fremont's eastern border. The bridge operated as the primary route for north-south traffic until it was torn down in 1917. (Courtesy MOHAI, 83.10.6877.1.)

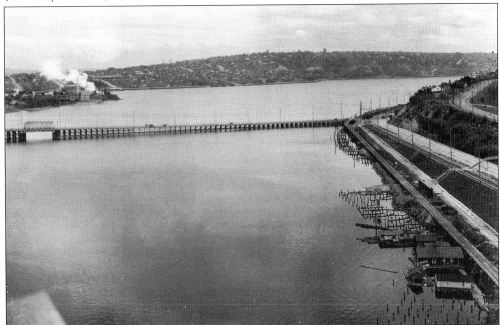

VIEW OF STONE WAY BRIDGE, MAY 4, 1916. Looking east across Lake Union towards Capitol Hill, this image offers another view of the temporary Stone Way Bridge, as well as Gas Works Park, which opened in 1906 and is marked by smoke in the distance. (Courtesy University of Washington Libraries, Special Collections, Lee 3296.)

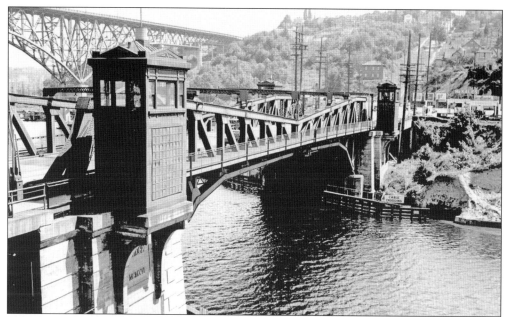

THE FREMONT BRIDGE BENEATH THE GEORGE WASHINGTON MEMORIAL BRIDGE. Although eclipsed in size by the George Washington Memorial Bridge, the Fremont Bridge has remained among the most loved features of the neighborhood's urban landscape. In 1982, the bridge achieved status as a city landmark and was added to the National Register of Historic Places. (Courtesy History House.)

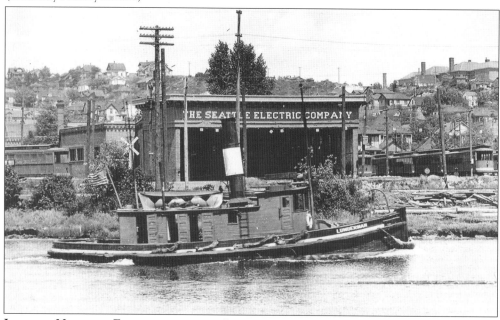

LOOKING NORTH AT FREMONT FROM THE CANAL, C. 1912. Transportation was a key component in attracting residents, businesses, and investors north of Seattle's downtown and into Fremont. Pictured here are two forms of transport, boats and streetcars, both of which had a significant impact on the character and growth of Fremont. The Seattle Electric Company was one of the city's earliest investors in an electric streetcar system (see pages 22–39). (Courtesy Mark Freeman.)

STREETCAR TRACKS AT FREMONT AVENUE AND NORTH THIRTY-NINTH STREET, DECEMBER 4, 1909. Long before Fremont's roads were paved, streetcars ran up and down the slope of Fremont Avenue carrying passengers from lower Fremont to Woodland Park and beyond. This house, at the southwest corner of North Thirty-ninth Street and Fremont Avenue, demonstrates the challenges of building on steeply graded land but also hints at the benefits of being located directly on a streetcar line. In 1889, Fremont Avenue was the sight of Fremont's first streetcar line, privately owned by Guy Phinney, who used streetcars to bring visitors up to his Woodland Park. (Courtesy University of Washington Libraries, Special Collections, Lee 324.)

STREETCAR TRACKS ON NORTH FORTY-THIRD STREET, JANUARY 1921. By the 1920s, many of Fremont's residential streets remained unpaved but were lined with streetcar tracks, making evident the fact that public transportation was the way one got around town. St. Paul's English Lutheran Church on Fremont Avenue is also pictured (see pages 62–67). (Courtesy University of Washington Libraries, Special Collections, SMR 271.)

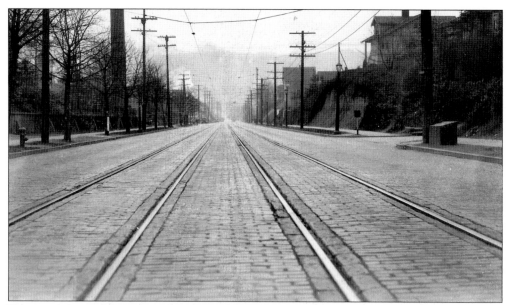

FREMONT AVENUE LOOKING SOUTH, FEBRUARY 15, 1930. This image captures the dramatic slope of Fremont's hill as it dives down towards the canal. Seattle's hilly landscape was the perfect place for electric streetcars due to the fact that vehicles that relied on horsepower often found that their four-legged "engines" tired easily or could not bear the strain of pulling wagons up steep hills. Note the electric wires above to which streetcars attached for their power source. (Courtesy University of Washington Libraries, Special Collections, SMR156.)

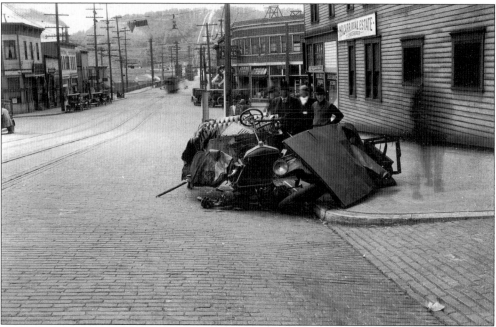

DAMAGED AUTOMOBILE, FREMONT AVENUE AND NORTH THIRTY-SIXTH STREET. While streetcars were the easiest and quickest way to travel in Seattle during the early part of the 20th century, they were also dangerous. This automobile has been hit by a streetcar and is totally destroyed. (Courtesy University of Washington Libraries, Special Collections, SMR 270.)

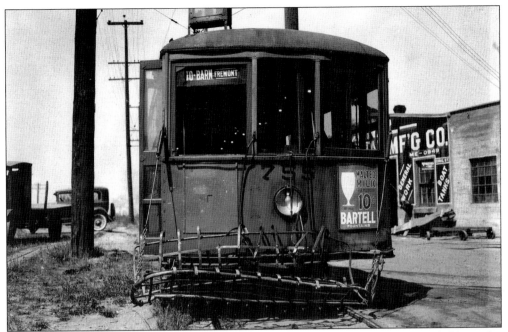

DAMAGED STREETCAR. This streetcar, with its damaged front-guard railing, was probably similar to one that ran into the automobile on the opposite page. Streetcar accidents were far from a rare occurrence on Seattle's streets and proved a constant concern for city officials. (Courtesy University of Washington Libraries, Special Collections, SMR 199.)

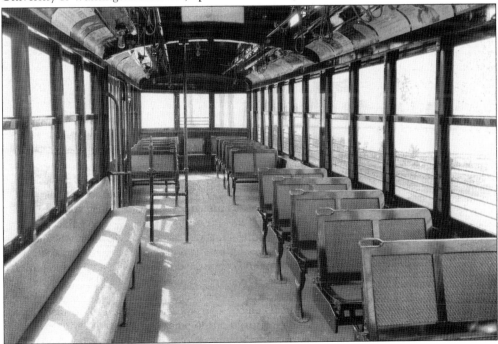

INTERIOR OF STREETCAR NO. 752, 1937. After 1937, car No. 752 was used along the Greenlake and Meridian lines that ran through Fremont multiple times per day. (Courtesy University of Washington Libraries, Special Collections, SMR 203.)

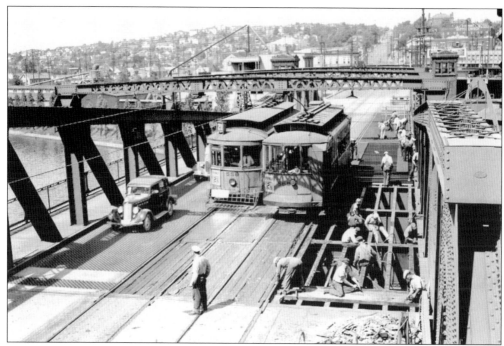

STREETCARS ON FREMONT BRIDGE. Despite construction in 1936, streetcars continued to travel regularly across the Fremont Bridge. Just five years later, in 1941, Seattle abandoned the streetcar system in favor of rubber-tired buses. (Courtesy Seattle Municipal Archives.)

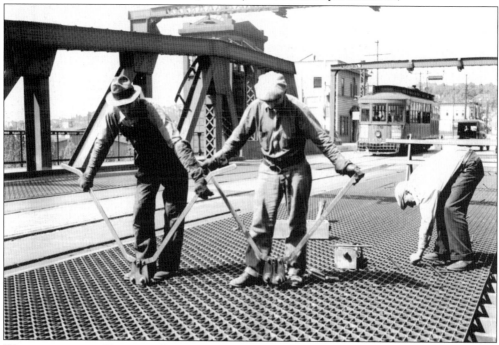

WORKERS ON THE FREMONT BRIDGE, OCTOBER 5, 1936. Pictured here, workers replace the old decking on the Fremont Bridge with the steel decking that remains today. (Courtesy Seattle Municipal Archives.)

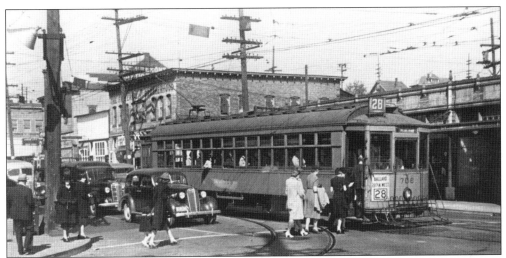

STREETCAR AT FREMONT AVENUE AND THIRTY-FOURTH STREET. A streetcar on line No. 28 through Ballard stops in front of the McKenizie Building at one of Fremont's major intersections. Despite the popularity of streetcars, Seattle abandoned the system in favor of rubber-tired buses in 1941. In its heyday, Seattle's electric streetcar system was the single most important form of transportation in the city. In fact, the 1914 Polk directory estimated Seattle's population to be 304,126 on January 1 of that year, and further noted that the average ridership for Seattle's streetcar lines during 1913 was 303,790 passengers daily! Other figures collected in 1916 suggest that the total number of riders taking one-way trips on Seattle's streetcar system for that year could be totaled at 105 million. (Courtesy History House.)

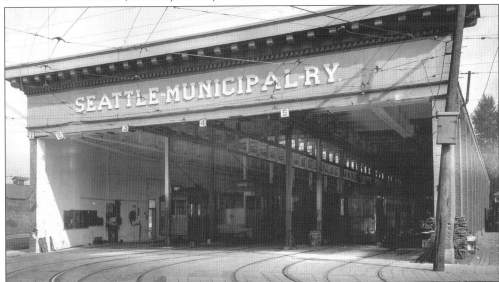

THE FREMONT CARBARN, NORTH THIRTY-FOURTH STREET AND PHINNEY AVENUE. Built in 1905 by the Seattle Electric Company (which was later merged into the Puget Sound Traction, Light, and Power Company), the Fremont carbarn was a significant component of Seattle's streetcar system. In 1919, the carbarn transferred ownership into the hands of the City of Seattle, and in April 1941, Seattle's last streetcar, No. 706, completed its final run by returning to Fremont's carbarn. In January 1992, the carbarn was added to the City of Seattle's list of historic landmarks. (Courtesy University of Washington Libraries, Special Collections, SMR 94.)

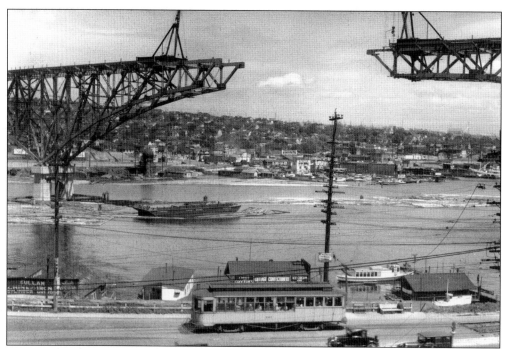

Constructing the George Washington Memorial Bridge. Designed by Jacobs and Ober, this cantilever bridge stretches 2,945 feet over Lake Union's northwest shores, looming over the Fremont Bridge below. More commonly referred to as the Aurora Bridge, because it connects Aurora Avenue (Highway 99) across the water, it was formally dedicated on George Washington's 200th birthday, February 22, 1932. (Courtesy History House.)

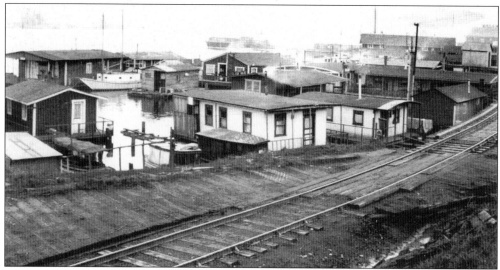

Houseboats beneath the Aurora Bridge. Cuddling the northern shores of Queen Anne, these houseboats rest under the Aurora Bridge, just across the water from Fremont. During the construction of the Lake Washington Ship Canal, investors bought land that rimmed Lake Union in anticipation of increased property values once the canal was open. Until the 1990s, when houseboat living fell into fashion, Seattle's houseboats remained a form of low-income housing. (Courtesy King County Archives.)

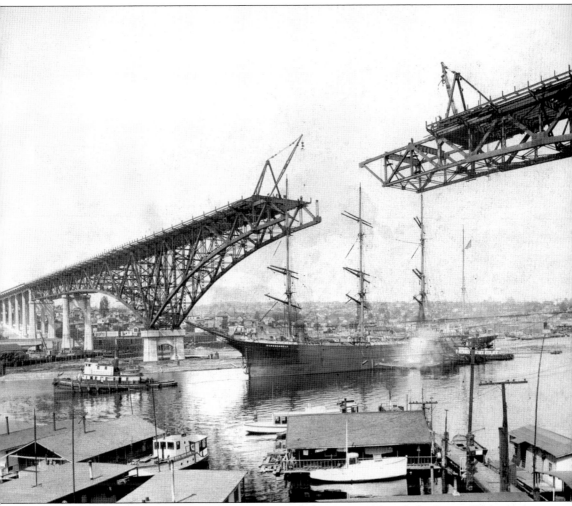

THE MONONGAHELA PASSES BENEATH THE UNFINISHED BRIDGE. Although the George Washington Memorial (Aurora) Bridge stands 167 feet above the water, its deck was still not high enough to allow the passage of the Pacific Northwest's great tall ships. The *Monongahela*, named after a river in Pennsylvania, was the last tall ship to pass beneath the bridge before its completion in 1932. (Courtesy Puget Sound Maritime Historical Society, 5902.)

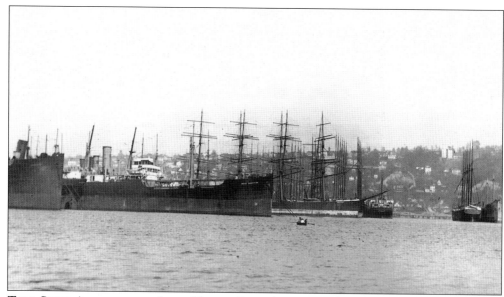

TALL SHIPS ANCHORED IN LAKE UNION. For a short time after the Lake Washington Ship Canal was completed and before the George Washington Memorial Bridge was finished, tall ships crowded the waters of Lake Union. This image is a dramatic reminder of Seattle's, thus Fremont's, connection with maritime history. (Courtesy Mark Freeman.)

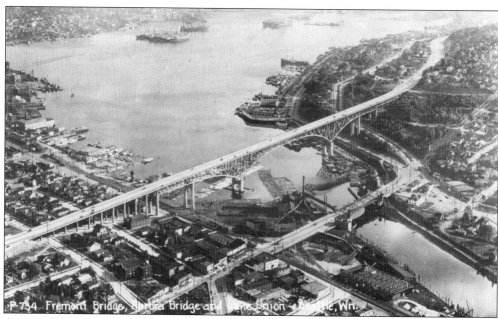

AERIAL VIEW, FREMONT'S BRIDGES. Standing side by side, the massive George Washington Memorial Bridge and relatively dainty Fremont Bridge function as pragmatic symbols of Fremont's growth and modernization. In 1982, both bridges were officially recognized as historic landmarks. (Courtesy University of Washington Libraries, Special Collections, UW17838.)

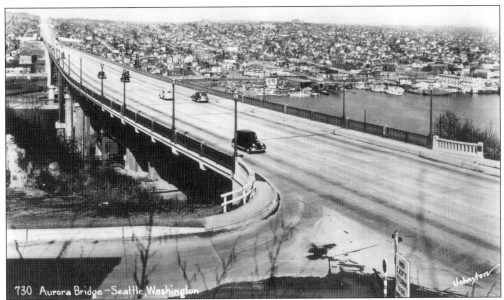

730 Aurora Bridge—Seattle, Washington

CARS CROSS THE AURORA BRIDGE. About two weeks after its opening, Frank Talmadge, a lifelong member of the Fremont Baptist Church, walked across Highway 99's Aurora Avenue bridge with his father. "My job," Talmadge recalls, "was to count the number of cars crossing in each direction. There were eight." Having returned home, Talmadge's father declared the George Washington Memorial Bridge to be "the biggest waste of tax payers money you'll ever see in your whole life!" (Courtesy University of Washington Libraries, Special Collections, UW26016.)

TRAFFIC ON HIGHWAY 99 AT AURORA AVENUE NORTH OF THE GEORGE WASHINGTON MEMORIAL BRIDGE. When originally conceived, Highway 99 had just two lanes of traffic in each direction, rather than the three it has today. Traffic over the bridge in the 1930s remained relatively quiet, in part due to the Depression, but in little time, the Aurora Bridge, rather than the Fremont Bridge became Seattle's primary north-south causeway. As daily traffic bypassed Fremont's downtown in favor of Highway 99, the district began to decline.

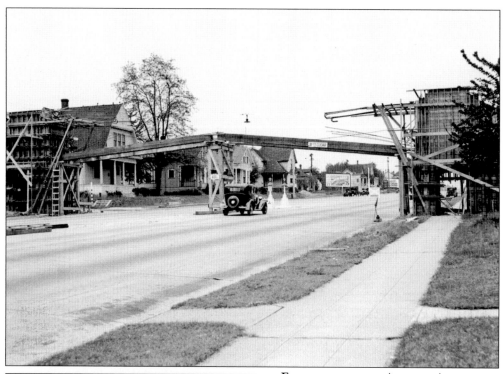

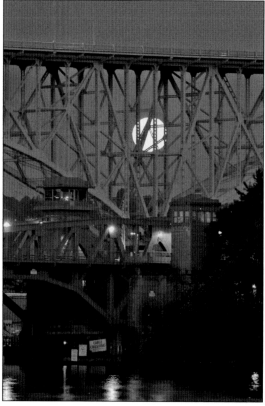

FOOTBRIDGE OVER AURORA AVENUE.
With the gradual increase in traffic over Fremont's Aurora Avenue due to the George Washington Memorial Bridge, concerns for pedestrian safety increased, particularly as B. F. Day Elementary School was located just one block to the west. In 1936, this footbridge was built in order to ensure a safe route across Aurora Avenue for those traveling by foot. (Courtesy Seattle Municipal Archives.)

MOON RISING OVER FREMONT'S BRIDGES. Connecting Seattle's busy downtown with Fremont's once forested hillside, these two iconic bridges are reminders of the cultural, commercial, and infrastructural stories that combine to create Fremont's history. The Fremont and "Aurora" Bridges are significant, not only for their architectural and historical impact but also for the aesthetic mark they etch on the city's landscape. (Courtesy John Cornicello.)

Two

FREMONT FACES
THE NEIGHBORHOOD GROWS

The site of major engineering endeavors, such as the Lake Washington Ship Canal and George Washington Memorial Bridge, 20th-century Fremont was also home to of hundreds families. These families, together with the dozens of small owner-operated businesses, churches, and other local social institutions, are to be credited with having built the foundations a community that, though altered somewhat today, continues to breath life into Fremont. The Fremont Baptist Church, for example, has been a reputable social institution since its establishment in 1892, and has offered hundreds of individuals a friendly environment in which to join with their neighbors in charitable work and worship. B. F. Day Elementary School has also been a solid fixture in the Fremont community, educating local children continuously since it was opened in 1892, and expanding its walls to accommodate for the neighborhood's increased population. The shops and houses that line Fremont's streets, moreover, are often-overlooked artifacts that demonstrate the motivations and materials that literally and figuratively structured Fremont's society.

The following chapter focuses on the institutions and businesses, as well as the people behind them, which have made significant contributions to building a rich community within Fremont's boundaries. Undoubtedly it is the faces of Fremont, rather than simply the infrastructure or industries that represent them, that have characterized this unique community.

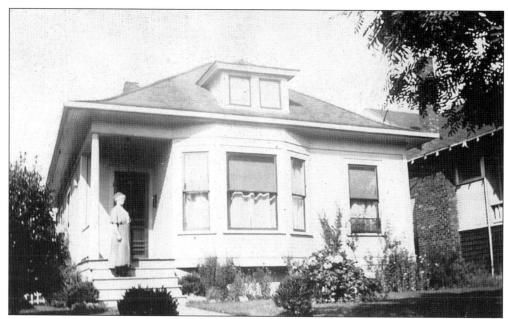

4113 LINDEN AVENUE. Fremont resident Lois J. Newers stands on the front steps of her home on Linden Avenue. Traditionally Fremont has been a working-class community whose residents have occupied modest but comfortable houses, such as the one shown here. (Courtesy Bob and Helen Pheasant.)

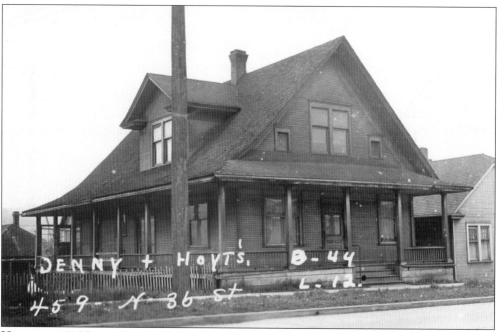

HOUSE AT 459 NORTH THIRTY-SIXTH STREET. One of Fremont's earliest houses, this home, with its impressive wraparound veranda, stands on what was once referred to as Kilbourne Street, after Fremont founding father, Dr. E. C. Kilbourne. Today it is home to one of the neighborhood's most beloved coffee shops, Sophia's Fremont Coffee, where locals can warm themselves for hours in small cozy rooms over the best Americano in town. (Courtesy Puget Sound Regional Archives.)

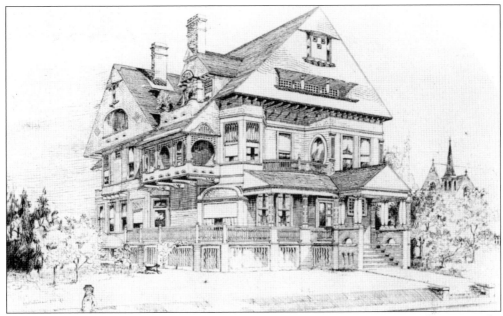

THE BOWMAN HOUSE. Though the majority of Fremont's residents came from modest means, the neighborhood, as this image shows, was not free of opulence. Designed for George Bowman by Willis A. Ritchie in 1893, this extravagant home was located on Bowman Avenue and Kilbourne Street (today's Woodland Park and North Thirty-sixth Street). In the distance, one can make out the roof of the Edgewater Congregational Church, established in 1889 under Rev. Morgan P. Jones as Fremont's first church. (Courtesy University of Washington Libraries, Special Collections, UW4749.)

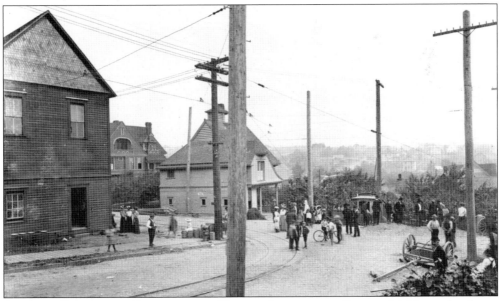

CROWDED RESIDENTIAL INTERSECTION. Housing along streetcar lines was highly sought after as it meant easy access to the rest of the city. Note the Bowman house to the left of the photograph, recognizable for its complex brickwork and elaborate balconies. (Courtesy University of Washington Libraries, Special Collections, UW4416.)

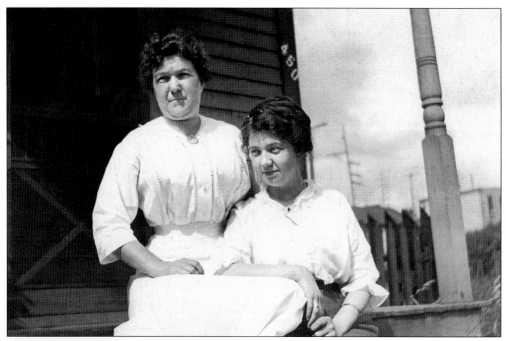

MOTHER AND DAUGHTER. Addie Case Preston and her daughter Ethel sit on the steps of their home, located at 450 Kilbourne Street (North Thirty-sixth Street). The wife of local butcher Weyland Case, Addie lived a relatively modest life. Her daughter Ethel, however, would be swept into a life of privilege after her marriage to successful local landowner and developer Jack Pheasant. (Courtesy Bob and Helen Pheasant.)

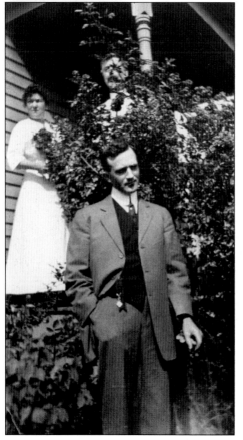

JOHN (JACK) PHEASANT. Having once worked as a streetcar operator, Jack Pheasant made a name for himself in the early part of the 20th century after committing to a number of lucrative investments in property located in Fremont and Ballard. He is pictured here standing in front of the house on 450 Kilbourne Street (North Thirty-sixth Street) that still stands today, directly east of Fremont Coffee. In the background are his wife, Ethel Mae Preston Pheasant, and his father-in-law, Weyland Preston. Note that the house sits higher than it does today, since the streets were raised. (Courtesy Bob and Helen Pheasant.)

THREE GENERATIONS OF A FREMONT FAMILY. Pictured here is early Fremonter Addie Preston, along with her daughter Ethel Pheasant, and grandson Robert (Bob) Pheasant. The Pheasants would eventually own much of the land that now comprises central Ballard, as well as downtown Fremont. (Courtesy Bob and Helen Pheasant.)

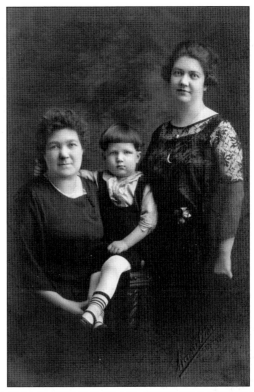

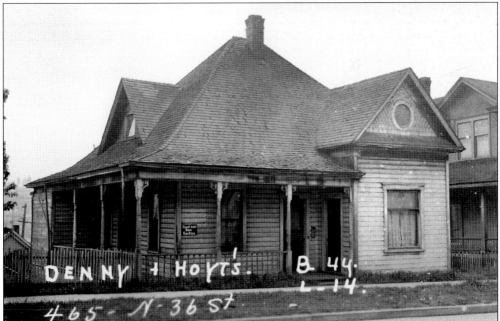

HOUSE AT 465 NORTH THIRTY-SIXTH STREET. For the first years of their marriage, Ethel and Jack Pheasant lived at 465 North Thirty-sixth Street, just down the street from the Prestons. Walking through Fremont today, one will note that this house still stands. (Courtesy Puget Sound Regional Archives.)

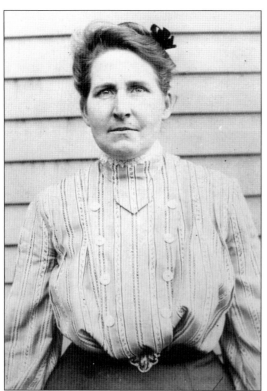

KATE WOOSTER. In 1889, Kate Wooster arrived in Seattle from the east with her husband and young son Harry. Members of the First Baptist Church, the Woosters were disappointed by the lack of a Baptist congregation in Fremont, thus they joined with eight other Fremont residents in an effort to establish what became known as the Fremont Baptist Church in 1892. (Courtesy Fremont Baptist Church.)

MR. AND MRS. A. G. WOOSTER ON THE STEPS OF THEIR FREMONT HOME. In 1892, at the urging of Mr. And Mrs. Wooster, an 85-foot-long chapel railroad car, the *Evangel*, paid Fremont a visit from Cincinnati. Curious local residents met in the *Evangel* in its temporary location at Fremont Avenue and Ewing Street (now North Thirty-fourth Street) for a worship service on March 20, after which they decided to organize the Fremont Baptist Church, calling Rev. W. H. Black to be their first pastor. (Courtesy Fremont Baptist Church.)

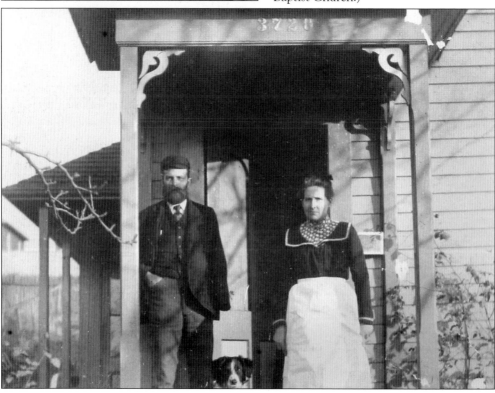

THE FREMONT BAPTIST'S FIRST CHURCH. In January 1900, after worshipping in rented store space for eight years, the Fremont Baptist congregation purchased two lots for just $450 in order to construct a wooden chapel. On March 24, 1901, the new wooden building was dedicated and opened its doors to 61 members. (Courtesy Fremont Baptist Church.)

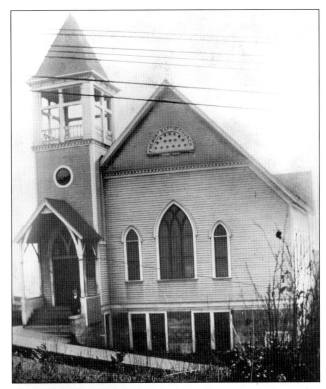

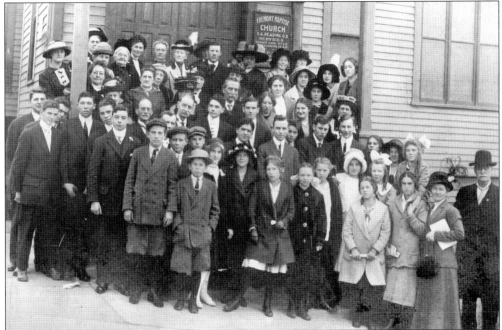

EARLY CONGREGATION IN FRONT OF THE FREMONT BAPTIST CHURCH. In 1909, just eight years after the church's building was completed, Fremont Baptist's membership had risen from 61 to 252. By 1931, the church boasted a membership of 662 individuals. (Courtesy Fremont Baptist Church.)

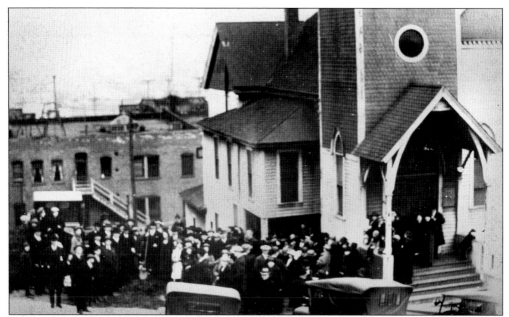

CONGREGATION GATHERS OUTSIDE THE FREMONT BAPTIST CHURCH. Throughout the 1910s, the Fremont Baptist Church's popularity continued to grow and attract new members. This photograph demonstrates the size of the congregation in relation to its increasingly inadequate building. Note also the building in the background. Built in 1911 at 708 North Thirty-fifth Street, this structure currently functions as an apartment building at one of Fremont's s intersections. (Courtesy Fremont Baptist Church.)

THE SMITH FAMILY. Pictured here is the first of four generations of Smith family to attend the Fremont Baptist Church. Florence Smith sits here with her two daughters, Susie (left) and Genevieve (right), and three sons, Jay (left), George (center), and Glen (right). Speaking of her days running the Fremont Hotel on Fremont Avenue and North Thirty-fifth Street (see page 82), Florence recalls that she charged boarders $5 a week and baked 10 pies every day to feed them—as many as her oven would hold. (Courtesy Fremont Baptist Church.)

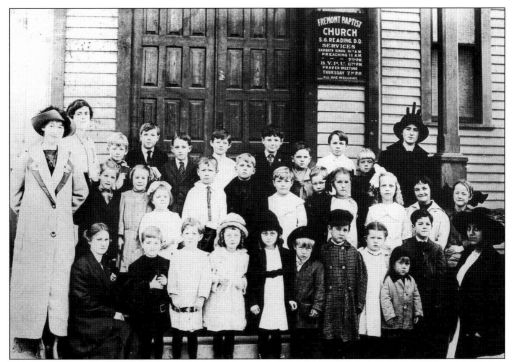

CHILDREN OF THE FREMONT BAPTIST CHURCH. Sunday school, which began at 9:00 each Sunday morning and was run by young female members of the church, was an essential part of the Fremont Baptist Church's weekly programs. (Courtesy Fremont Baptist Church.)

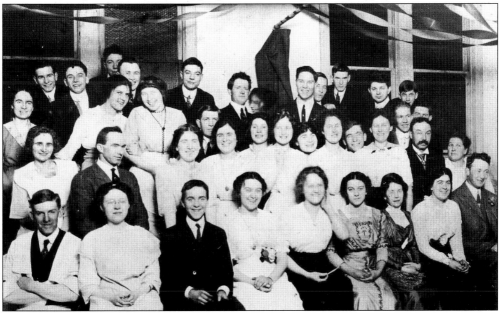

PARTY FOR YOUNG CHURCH MEMBERS. In addition to being a place for families to worship on Sundays, the Fremont Baptist Church also offered teenagers and young adults opportunities to meet their peers, make friendships, and generally enjoy themselves. (Courtesy Fremont Baptist Church.)

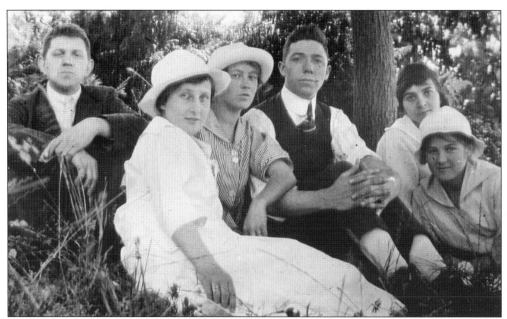

YOUNG FRIENDS ENJOY A DAY IN THE SUN. Byron Talmadge (left) and Jesse Willits (third from right) enjoy a day outside with young ladies from the Fremont Baptist Church. Both Talmadge and Willits were active church members, participating in its sports and music programs. (Courtesy Fremont Baptist Church.)

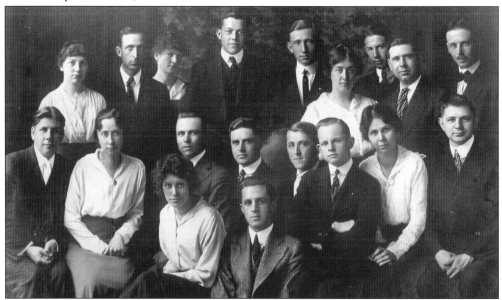

PORTRAIT OF FREMONT BAPTIST CHURCH MEMBERS. The passionate and loyal involvement of church members, young and old, in the Fremont Baptist Church's programs was precisely what enabled the congregation to grow and flourish during the first decades of the 20th century. This group of young adults, many of whom grew up in the church, are the same faces who helped support and organize a number of the church's regular events and programs such as the "Agoga" class for young single men, and the "Amoma" class for young single women. In 1923, these two groups merged into one and took the name "Double A." (Courtesy Fremont Baptist Church.)

THE SMITH FAMILY CHILDREN. Dorothy, George, Gordon, and Ben represent the third generation of the Smith family to attend the Fremont Baptist Church, following the lead of their grandmother Florence Smith (see page 53), who became a member during the church's early days. Gordon Smith (second from the left) grew up in Fremont with his brothers and sister on North Forty-third Street and Linden Avenue. To this day, he continues to attend the church's weekly services and is the director of the church's choir. (Courtesy Fremont Baptist Church.)

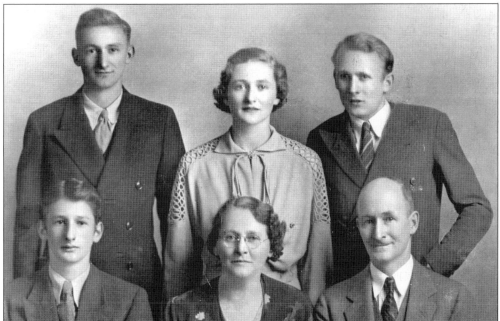

THE SMITH FAMILY, C. 1940. This family of six represents the second and third generations of the Smith family to reside in Fremont and attend the Fremont Baptist Church. Pictured, from left to right, are (first row) George, Edith, and Glen; (second row) Gordon, Dorothy, and Ben. (Courtesy Fremont Baptist Church.)

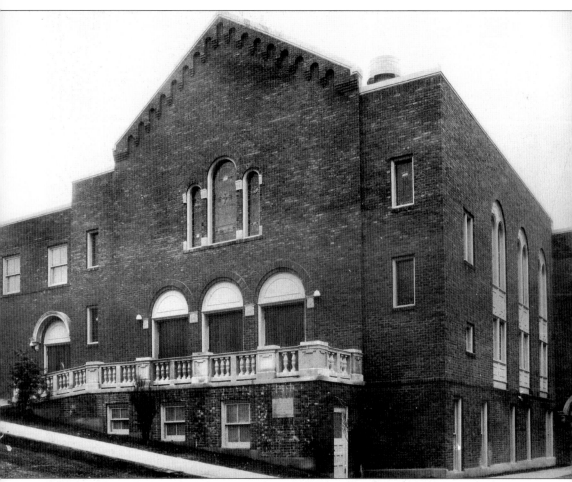

Fremont Baptist Church's New Building. With the rapidly increasing size of its membership, the Fremont Baptist Church soon outgrew the charming wooden chapel that had housed its congregation since 1901. To alleviate this problem, three additional lots of land were purchased between 1919 and 1924, and on December 7, 1924, a new red brick building was dedicated. Although the original plans for the building had called for a large rosette window on the new church's primary north wall, as well as an ornate tower connected to a small west wing, plans were revised and simplified to create the still large structure, which crowns the slope of North Thirty-sixth Street today. (Courtesy Fremont Baptist Church.)

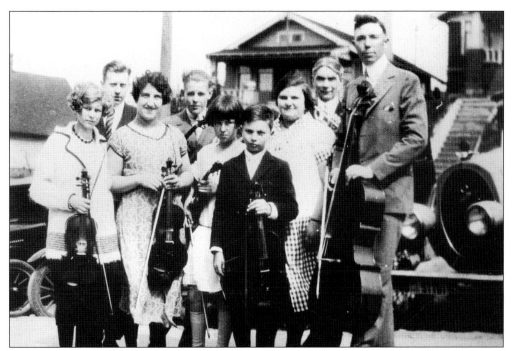

MUSICIANS AT FREMONT BAPTIST. Cellist and longtime church member Jesse Willits stands with other musicians in front of the Fremont Baptist Church. Across the street and behind the group, one can see the modest style of house typical in Fremont. (Courtesy Fremont Baptist Church.)

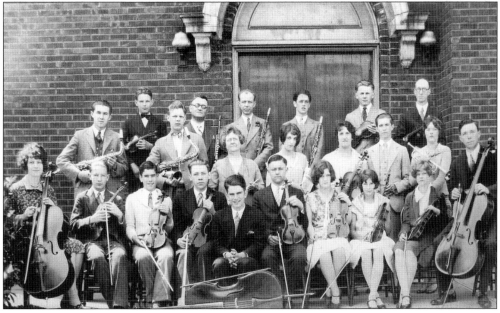

THE FREMONT BAPTIST CHURCH ORCHESTRA. Musicians of the Fremont Baptist Church gather in front of the new church building completed in 1924. About 20 years later, on November 7, 1943, Rev. St. Elmo Nauman proudly lead the ceremonial burning of the mortgage to mark an end to the debt incurred from building this newer and larger structure. (Courtesy Fremont Baptist Church.)

57

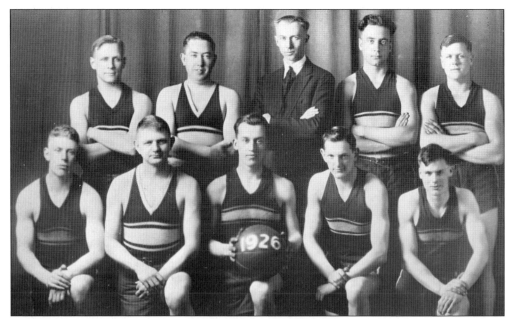

FREMONT BAPTIST CHURCH BASKETBALL TEAM, 1926. In addition to providing opportunities for Fremonters to meet friends, play music, and worship, the Baptist church was also a place where young men could participate in citywide league sports. Pictured, from left to right, are (first row) Bert Hobbs, Byron Talmadge, Brad Bartlow, Bill Wagner, and George Hostland; (second row) Bob Holmstrom, Rudy Beamer, Clarence Mostue, Cecil Brown, and Alfred Brown. (Courtesy Fremont Baptist Church.)

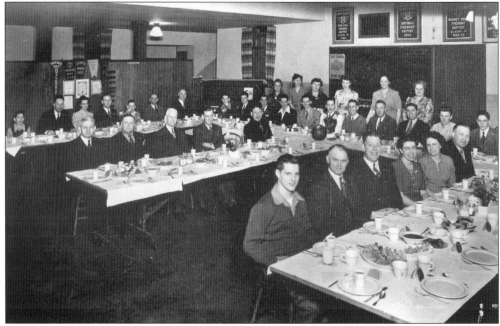

BASKETBALL BANQUET, C. 1940S. The Fremont Baptist Church celebrates the participation and success of its basketball teams within the city of Seattle. Churches all over the city participated in basketball tournaments that were comprised of three classes of teams, A through C, determined by the age of the teams' players. (Courtesy Fremont Baptist Church.)

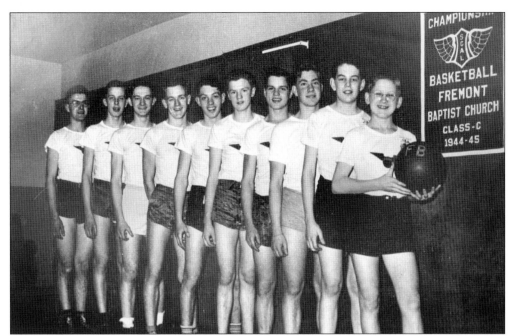

FREMONT BAPTIST'S CLASS C BASKETBALL TEAM, 1944–1945. The young men of Fremont Baptist's Class C basketball team in 1944–1945 were, from left to right, unidentified, unidentified, Wally Hedges, Jim Buckingham, Elbert Beamer, unidentified, Bob Sand, unidentified, Wally Bartlow, and Jim Morrison. (Courtesy Fremont Baptist Church.)

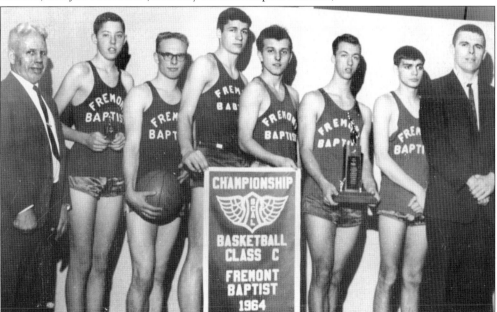

FREMONT BAPTIST'S CLASS C BASKETBALL TEAM, 1964. In 1964, under the coaching of former prizefighter Harold "Gully" Gulbrandsen, the Fremont Baptist Church's Class C basketball team won the Seattle Church Athletic League championship. Champion team members, from left to right, are Coach Harold Gulbrandsen, Dave Roberts, Don Gilbert, Rick Swindler, John Korvin, Benny Babcock, Jimmy Lehman, and John Lyttle. (Courtesy Fremont Baptist Church.)

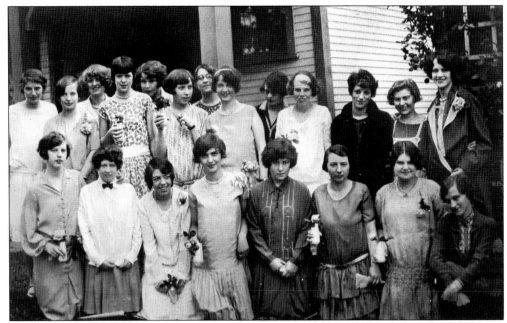

FREMONT BAPTIST'S YOUNG LADIES, C. 1920s. While the young men of the Fremont Baptist Church participated in sports, the church's young women also had multiple opportunities to socialize. Here a group of young ladies, holding small flower arrangements, gather on a warm day. (Courtesy Fremont Baptist Church.)

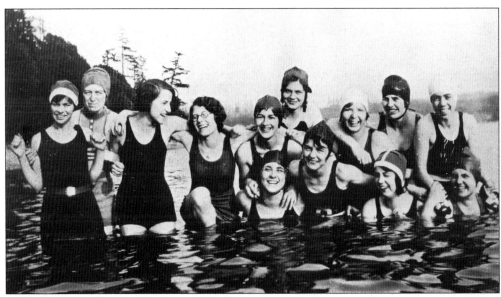

YOUNG WOMEN SWIMMING, C. 1928. Each summer, members of the Fremont Baptist Church looked forward to relaxing and playing at Camp Burton, a facility owned by the Baptist Convention on Vashon Island. Pictured here, from left to right, are (first row) Amber Cottrell, Roberta Greisinger, Mabel Neese, and Helen Beamer; (second row) Mary Kendall, Katie Hobbs, Edna Pettican, Elvera Jellen, Helen Bartlow, Agnes Johnson, Vessa Owen, Christina Hobbs, and Ethel Hilton. (Courtesy Fremont Baptist Church.)

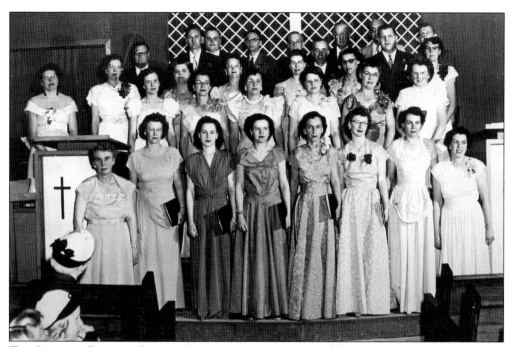

THE CHOIR AT FREMONT BAPTIST CHURCH, 1950s. Music, and choir in particular, was among the most important church activities that men and women enjoyed participating in together. Among those picture are Gordon Smith (top row, second from the left—see page 55), Frank Talmadge (top row, third from the right—see page 43), and Norma Holmes Handorf Honn (second row, third form the left—see page 79). (Courtesy Fremont Baptist Church.)

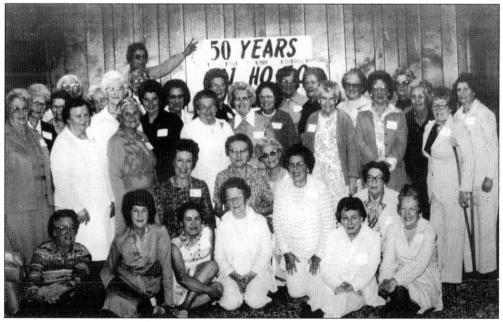

FAHOLO CELEBRATES 50 YEARS. FAHOLO, short for faith, hope, and love, was a long-established women's group that brought female members of the Fremont Baptist Church together for charitable and community projects. (Courtesy Fremont Baptist Church.)

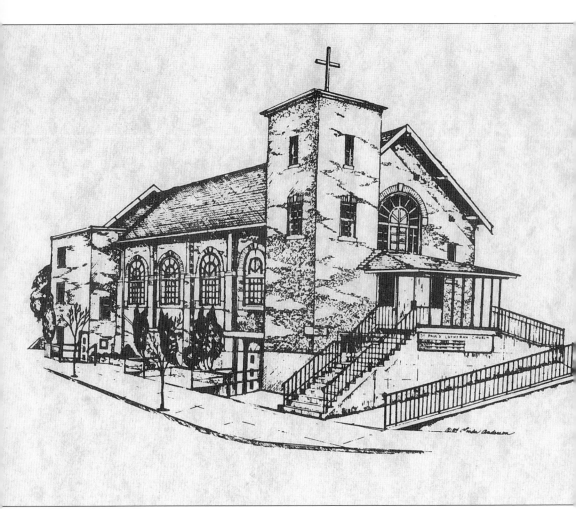

ST. PAUL'S ENGLISH LUTHERAN CHURCH, C. 1950S. Similar to the Fremont Baptist Church, St. Paul's English Lutheran Church, so called because its sermons were presented in English rather than in Swedish, Danish, or Norwegian like other local Lutheran churches, was also instrumental in building young Fremont's sense of community. In 1910, at the request of the Whitten family of Fremont, the General Synod and Board of Home Missions granted permission to establish a Lutheran congregation in Seattle. By 1911, services had begun in the Masonic temple on Fremont Avenue under the leadership of Rev. Dr. John Brauer. By 1913, St. Paul's was officially accepted as an active parish. (Drawing by Linda Anderson, courtesy St. Paul's Lutheran Church.)

St. Paul's English Lutheran Church, c. 1914. Following its official recognition as an active parish in 1913, St. Paul's congregation purchased a lot of land at North Forty-third Street and Fremont Avenue in anticipation of constructing a church. On July 19, 1914, Seattle mayor Hiram Gill broke ground for the new church, and as early as March 1915, St. Paul's occupied its very own towered brick building. (Courtesy St. Paul's Lutheran Church.)

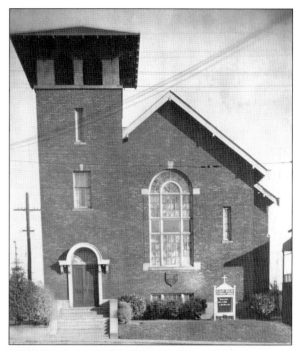

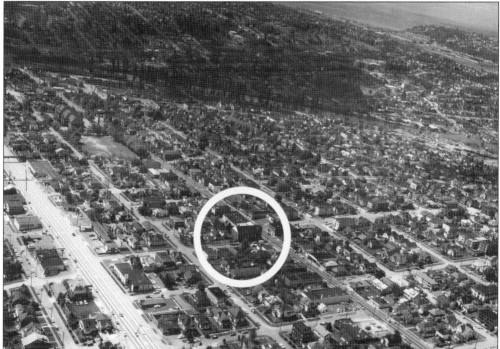

Aerial Photograph of Fremont Looking Southwest toward Queen Anne. This aerial photograph of Fremont taken during the 1960s shows the location of St. Paul's Church in relation to the rest of the neighborhood—uphill and north of Fremont's downtown. Also visible is the Lake Washington Ship Canal cutting across the upper portion of the photograph. Aurora Avenue and B. F. Day School are in the upper left corner. (Courtesy St. Paul's Lutheran Church.)

St. Paul's Confirmation Class, 1929. In 1924, five years before this photograph was taken, St. Paul's congregation, then presided over by Rev. J. P. Beason, installed a pipe organ in its sanctuary. This picture shows the confirmation class of 1929, along with Rev. Kunzman, in front of the pipe organ. Decades later, during the church's remodeling in 1954, the organ was removed. (Courtesy St. Paul's Lutheran Church.)

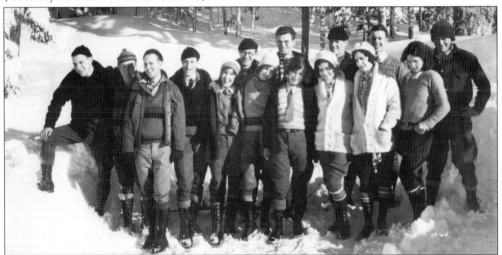

Weekend Outing to Mount Rainier, St. Paul's English Lutheran Church Luther League, 1927. In the early part of the 20th century, Fremont's churches were not simply institutions where residents worshiped on Sundays. Rather they were centers for community service and social interaction. The Luther League, shown here, was one of the many church-organized groups that provided young men and women with opportunities to make friends and stay active in their community. Pictured, from left to right, are Howard Helmick, Milton Klug, Carl Klug, Mel Metz, Marie Metz, Dave Metz, unidentified, Ray Canedy (with skis), Gladys Fritz, Evelyn Edenholm, Art Cagan, Anita Frazer, Herbert Edenholm, unidentified, and unidentified. (Courtesy St. Paul's Lutheran Church.)

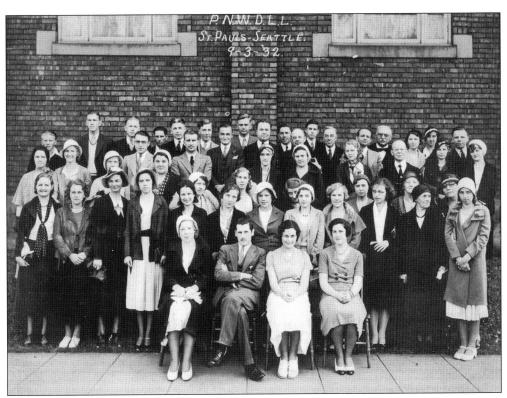

PACIFIC NORTHWEST DIVISION OF THE LUTHER LEAGUE, SEPTEMBER 9, 1932. This photograph, taken next to St. Paul's north wall, shows the diversity in ages of those who regularly attended and participated in church events and charitable groups. (Courtesy St. Paul's Lutheran Church.)

ST. PAUL'S CHURCH AFTER ITS REMODEL, 1954. During the 1950s, St. Paul's experienced an active and expanding congregation, which made necessary the need for an expanded and modernized building. In 1953, St. Paul's established a building fund campaign in order to raise money for the expansion and improvement of its building, and by 1954, the remodel, which included the removal of the church's signature tower, was complete. (Courtesy St. Paul's Lutheran Church.)

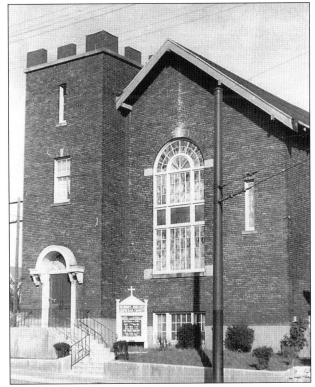

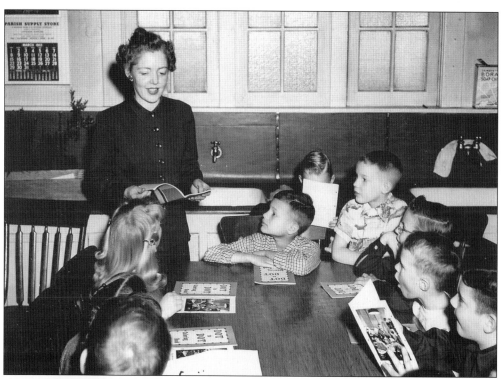

SUNDAY SCHOOL AT ST. PAUL'S, 1953. Murial Little, pictured here leading a class of youngsters, was a longtime and much loved teacher at St. Paul's Sunday school. (Courtesy St. Paul's Lutheran Church.)

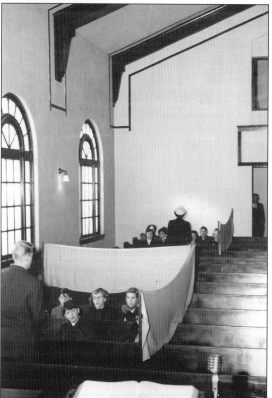

SUNDAY SCHOOL AT ST. PAUL'S, 1950S. By the 1950s, St. Paul's membership, and the subsequent number of youngsters enrolled in Sunday school, grew to such a number that Sunday school classes had to be held in makeshift "classrooms" within the church's sanctuary. (Courtesy St. Paul's Lutheran Church.)

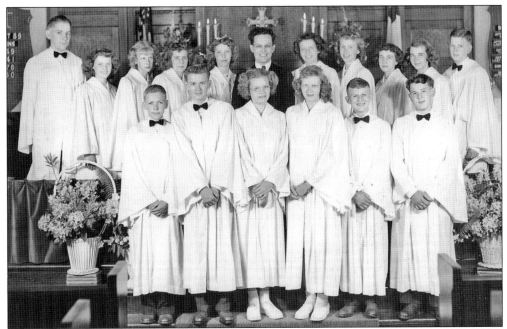

St. Paul's Confirmation Class, Early 1950s. This white-robed confirmation class stands with Rev. Edwin Bracer in front of the church's beautiful wooden alter and pipe organ before both were removed during the remodeling of the church building in 1954. (Courtesy St. Paul's Lutheran Church.)

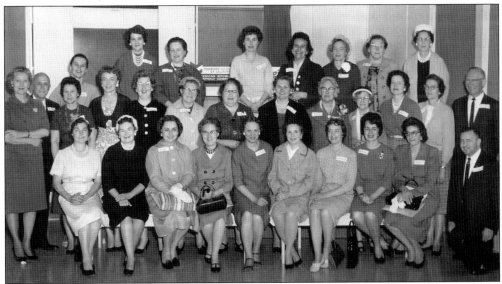

St. Paul's Ladies Aid Group. Women's groups, generally made up of busy housewives and mothers, were vital to keeping the church community involved in charitable works and community service. This group of women is posing for a picture after visiting the Standard Oil Company Plant in 1962. A letter sent to this group from Standard Oil after their site visit reads, "The purpose of these tours is to present an opportunity to housewives and mothers for better understanding of local industry, the part it plays and the contributions it makes to economic growth of the community." (Courtesy St. Paul's Lutheran Church.)

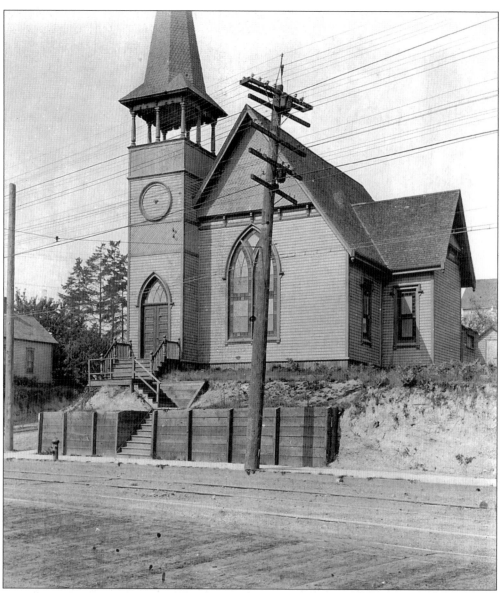

CHURCH OF JESUS CHRIST OF LATTER-DAY SAINTS, 1910. Located on the northeast corner of First Avenue Northwest and North Thirty-sixth Street (then Kilbourne Street), the Church of Latter-day Saints was another religious group that made its mark on Fremont's landscape. Listed at this same address at a later date was a Presbyterian church, which most likely took over the building. Fremont was an undeniably Christian society, and the number of churches within its boundaries is evidence to this fact. Other churches that are known to have served Fremont's community include the Methodist church at North Fortieth Street and Whitman Avenue, St. James Episcopal Church at North Thirty-eighth Street and Stone Way, and the Independent Presbyterian Church on Dayton between North Forty-second and Forty-third Streets. (Courtesy University of Washington Libraries, Special Collections, Lee 294.)

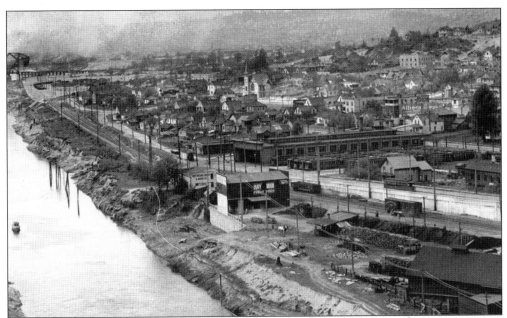

VIEW OF FREMONT LOOKING WEST, 1916. In this view of Fremont, one can just make out the steeple of the church located on North Thirty-sixth Street and First Avenue Northwest, as well as the carbarn. (Courtesy MOHAI, 2006.7.1.)

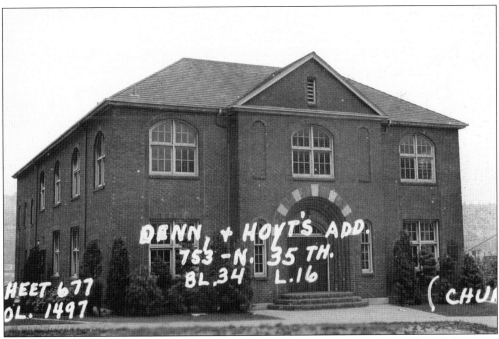

CONGREGATIONAL CHURCH, C. 1937. Taken from the property record card files of the Puget Sound Regional Archives, this is one of the only known photographs of this building while it functioned as a church. Now a multiuse office building tucked beneath the George Washington Memorial Bridge, the structure has undergone a number of renovations but retains its basic shape and character. (Courtesy Puget Sound Regional Archives.)

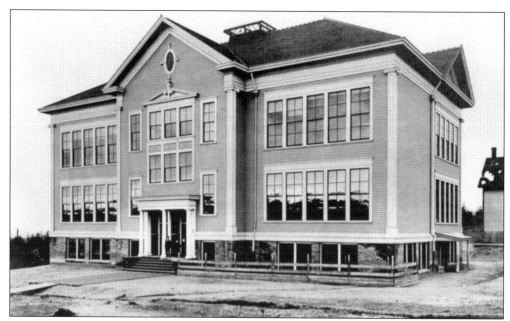

ROSS SCHOOL. In 1873, Fremont's first white settlers, John and Mary Ross, opened a school in their home in order to spare their children from the long, daily journey to school across Lake Union and through downtown Seattle. Ross School was Fremont's first school and operated from the Ross home on the northern banks of the canal ditch, until this building was constructed in 1903 on Third Avenue Northwest and North Forty-third Street. (Courtesy MOHAI, 17501.)

INTERIOR OF THE JOHN ROSS HOME. Taught by Lena Penfield for $20 per month plus room and board, Ross School's first classes were held upstairs in the Ross's own home. Within a year, however, the classroom was relocated downstairs due to the mud tracked in by the children's shoes. (Courtesy History House.)

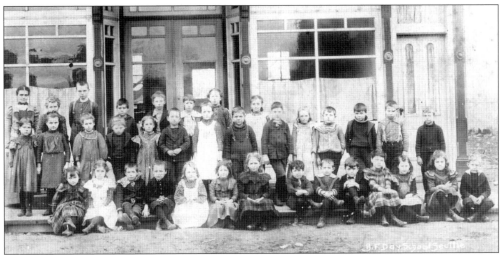

STUDENTS AT THE B. F. DAY SCHOOL. In 1889, what would eventually become the B. F. Day School was opened in the home of the Steele family on Whitman Avenue and Kilbourne (North Thirty-sixth) Street. A short time later, the school relocated down the street, with its 35 students, to the home of Mrs. Gale. In little time, however, student enrollment had overgrown the house's capacity, and an alternative building had to be found. Pictured here, students and their teacher, Miss Giles, stand before a Fremont storefront that served as a temporary classroom. (Courtesy Seattle Public School Archive, 218-1.)

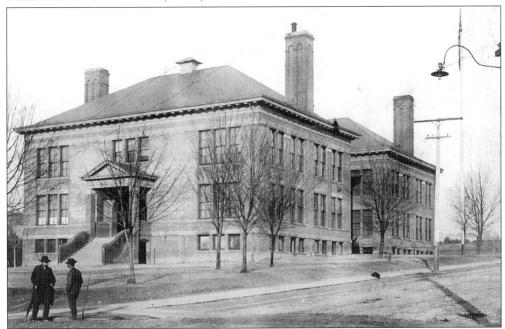

THE B. F. DAY SCHOOL. Due to a generous donation of land from Benjamin Franklin and Frances Day, a wealthy local couple with no children of their own, a large schoolhouse designed by J. Parkinson opened to Fremont's children on September 6, 1892, taking the name of its benefactors. By 1902, however, the original school building had already grown too small for the increased student enrollment. Pictured here is the original B. F. Day School building along with its 1902 northern addition designed by architect James Stephen. (Courtesy Bob and Helen Pheasant.)

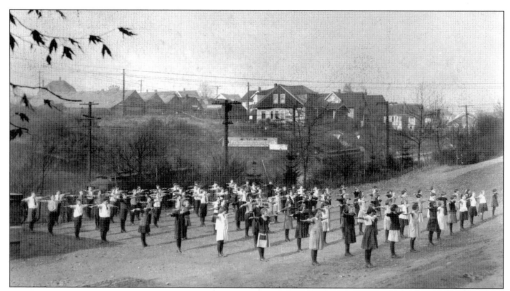

FLAG SALUTE AT B. F. DAY ELEMENTARY SCHOOL. This photograph of B. F. Day's students provides an interesting glimpse of the landscape that surrounded the school in the early part of the 20th century. Following the school's expansion in 1902, north and south wings designed by Edgar Blair were completed in 1916, accompanied by a boiler house on Fremont Avenue and North Thirty-ninth Street that connected to the school building via an underground tunnel. (Courtesy Seattle Public School Archives, 218-8.)

STUDENTS AT THE B. F. DAY PLAYFIELD. Outside exercise was, of course, just as important to B. F. Day's young student as the "3 R's" taught indoors. From this picture, looking north, one can just make out the tower of St. Paul's Lutheran Church peeking over the top of the large, white, rectangular building in the distance. (Courtesy Seattle Public School Archives, 218-20.)

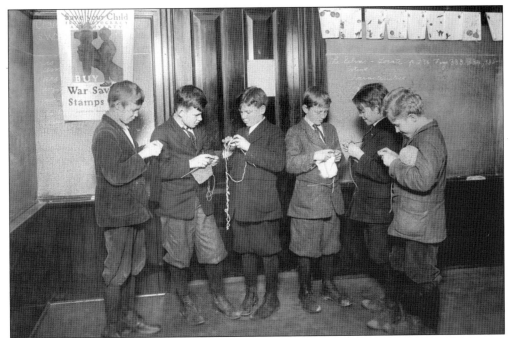

BOYS KNITTING. On January 23, 1918, when this photograph was taken at B. F. Day Elementary School, the First World War continued to ravage Europe. Teaching youngsters to knit and mend their clothes was one of the many exercises used to instruct students on the importance of conservation on the home front. Attached to the backboard, a poster reads, "Save Your Child From Autocracy and Poverty: Buy War Sav[ings] Stamps." (Courtesy Seattle Public School Archives, 218-20.)

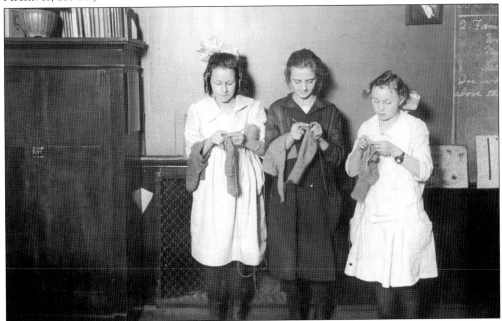

GIRLS KNITTING. Like their male peers above, girls, too, try their hand at knitting. (Courtesy Seattle Public School Archives, 218-16.)

CLASSROOM AT B. F. DAY. In the 1920s, some of B. F. Day's classrooms continued to be divided according the gender. Here boys practice their penmanship. (Courtesy Seattle Public School Archives, 218-14.)

BOYS IN SHOP CLASS, C. 1927. During the 1920s, a standard in B. F. Day's curriculum was hands-on work for young men. Robert M. Peoples, who attended B. F. Day from 1927 to 1933, recalls "the many hours spent tending nearby school crossings as a 'Schoolboy Patrolman,' often with rain dripping from my nose. What a treat it was for us when Sgt. Kimbal of the Seattle Police Department would stop by to give us a word of praise or encouragement." (Courtesy Seattle Public School Archives, 218-5.)

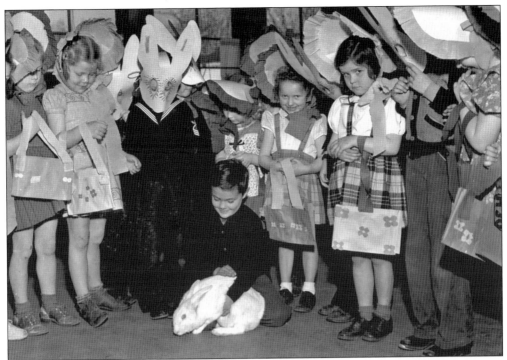

Easter Party at B. F. Day. The 1945 B. F. Day kindergarten class celebrates Easter with costumes and a white rabbit, held by a young Gayle Heagy. (Courtesy MOHAI, Seattle PI- 25475.)

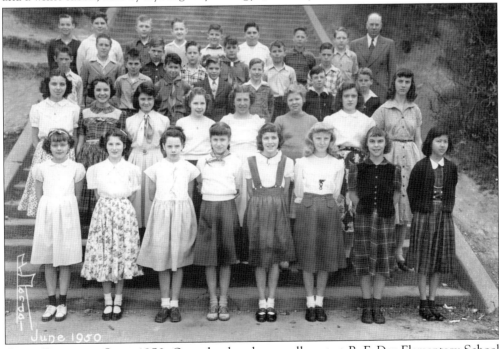

Class Portrait, June 1950. Over the decades, enrollment at B. F. Day Elementary School continued to increase. Even as Fremont began its decline in the 1940s and 1950s, attendance at the school remained steady. (Courtesy Seattle Public School Archives, 218-29.)

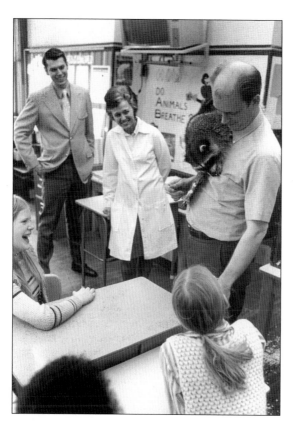

SCIENCE CLASS, 1972. Students receive an entertaining lesson in natural sciences and wildlife. In 1971, one year before when this picture was taken, B. F. Day's sixth graders were transferred to Hamilton Junior High, reducing the strain on the school's facilities. (Courtesy Seattle Public School Archives, 218-48.)

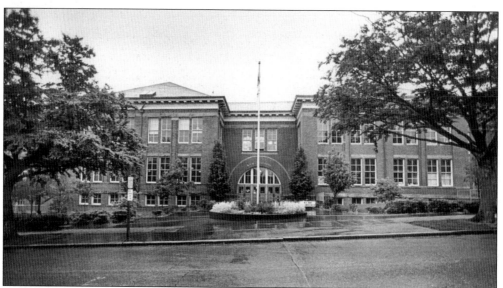

B. F. DAY TODAY. The longest, continuously operating school in the Seattle Public School District, B. F. Day continues to educate Fremont's children today. Except for a temporary move to the John Hay Building while the school was being renovated (1989–1992), B. F. Day has operated from its original 1892 building. In April 1981, the building was approved as a historic city landmark. (Courtesy Seattle Public School Archives, 218-46.)

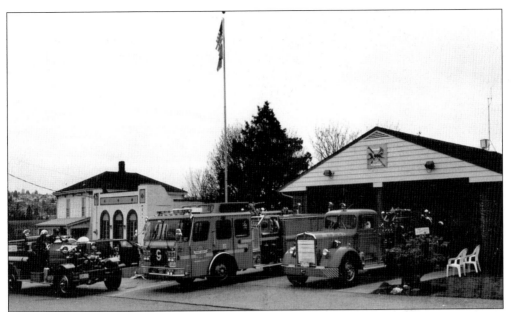

FREMONT'S STATION NO. 9, CENTENNIAL CELEBRATION, 1996. Just one block south of B. F. Day, Fremont's own fire station—Station No. 9—has occupied the same spot at Linden Avenue and North Thirty-ninth Street since 1902. Engine Company No. 9 first operated in 1886 from 402 Fifteenth Avenue East. Lolabel Fritz, who attended B. F. Day from 1921 to 1928 recalls looking out of her classroom window and watching "the fire station's men rush out during the day, driving the four horses who were pulling the fire wagon." (Courtesy Seattle Fire Department, Station No. 9.)

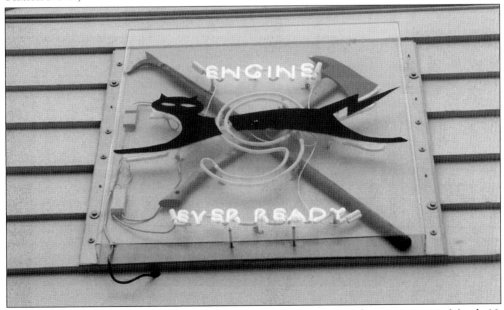

THE "EVER-READY" CAT. In recognition of the station's centennial anniversary on March 16, 1996, local artists Rodman Miller and Llyle Morgan presented Station No. 9 with this sign, complete with the station's mascot—the ever-ready cat—on behalf on the Fremont Arts Council. (Courtesy Seattle Fire Department, Station No. 9.)

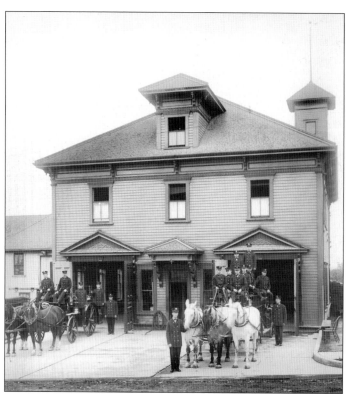

LADDER NO. 5 AND HOSE NO. 9, C. 1916. While Station No. 9 remains at the same location, it once occupied a very different building than it does today. The station's original wood-framed building, seen here, was characterized by unusually ornate door frames and a tower at the rear, which provided the station not only with a clean view of the area but also a place to practice drills. In 1952, this building was torn down in favor of the newer structure that remains today. (Courtesy Last Resort Fire Department.)

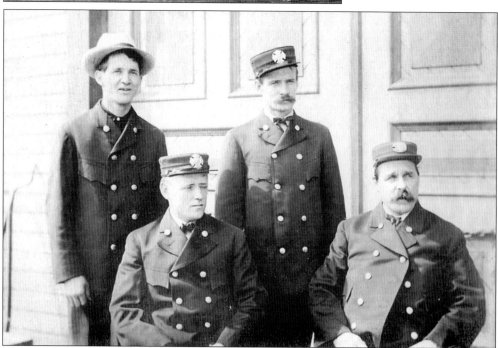

THE MEN OF STATION NO. 9, C. 1908. Pictured, from left to right, are L. P. Davis, John McCloud, F. A. Watling, and Capt. J. J. Longfellow. On December 15, 1910, Capt. Jacob J. Longfellow was killed in the line of duty. (Courtesy Last Resort Fire Department.)

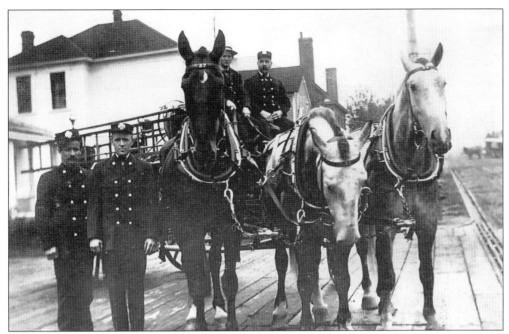

HORSE-DRAWN COMBINATION, 1908. Although the Seattle Fire Department began to motorize its rigs in 1910, Station No. 9 was not fully motorized until 1924. This "combination" wagon—so called because it combined a hose wagon with a chemical rig—was pulled up and down Fremont's steep slopes at top speeds by only three horses. (Courtesy Last Resort Fire Department.)

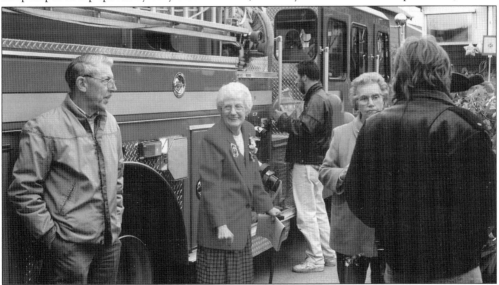

NORMA HOLMES HANDORF HONN AT STATION NO. 9'S CENTENNIAL ANNIVERSARY, 1996. Born in 1922, Norma has spent nearly her entire life in one of the cozy homes just across the street from Station No. 9. As a child, Norma recalls sliding down the pole at old Station No. 9 in the arms of the firemen who were assigned there. In recent years, before her move to an apartment north of Fremont, Norma established herself as somewhat of a surrogate mother to the station's men, baking them treats and regularly joining them for meals. (Courtesy Seattle Fire Department, Station No. 9.)

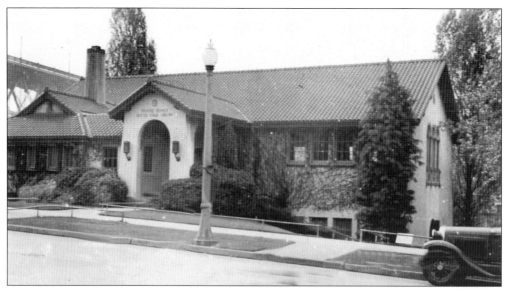

THE FREMONT LIBRARY, C. 1937. Thanks to a generous donation of $35,000 from Andrew Carnegie, the Fremont Branch of the Seattle Public Library opened in 1921. It was the last of Seattle's libraries funded through Carnegie, but not the first of Fremont's libraries. As early as 1901, Fremont had its own public reading room, organized by Fremonter Erastus Witter and located at the second floor of the Fremont Drug Company at Fremont Avenue and Blewett (North Thirty-fourth) Street. By 1903, this privately funded reading room became the Seattle Public Library's first branch. (Courtesy Puget Sound Regional Archives.)

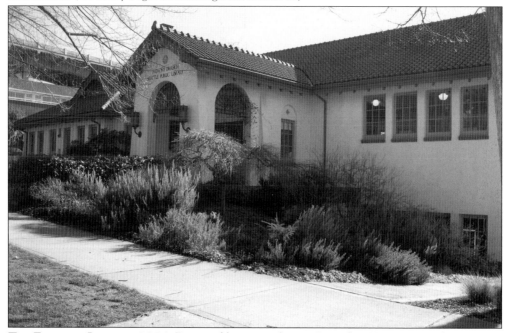

THE FREMONT LIBRARY, 2006. Designed by city architect, Daniel R. Huntington, the Fremont Branch of the Seattle Public Library has retained its original "Italian farmhouse" charm despite major renovations in 1984 and 2004. It is now listed on the National Register of Historic Places and has been officially recognized by the city as a historic city landmark. (Courtesy author.)

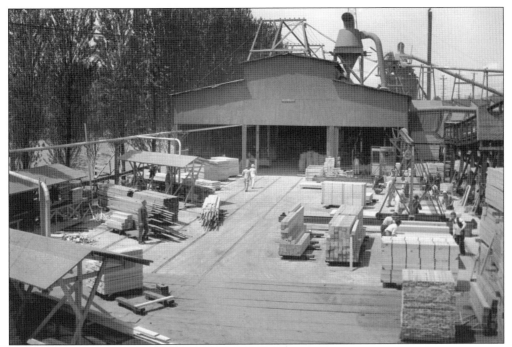

BURKE MILLWORK COMPANY, 1944. In 1939, J. R. Burke, owner of the nearby Brooklyn Mill in Seattle's University District, purchased the 20-acre site where the Bryant Lumber Mill, closed since 1932 due to a massive fire, once stood. At its new location, Burke's mill produced sashes and door frames for nearly 20 years, thereby keeping Fremont's industrial roots alive. By the end of the 1950s, the mill closed and Burke converted his land into an industrial park. (Courtesy MOHAI, 83.1014870.10.)

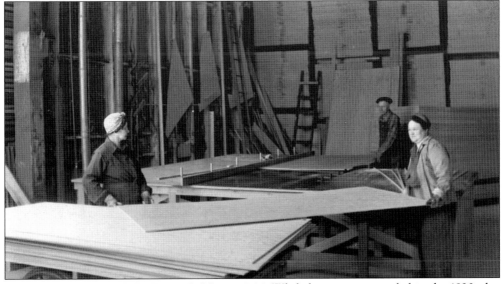

WOMEN AT WORK IN J. R. BURKE'S MILL, 1944. While businesses struggled in the 1930s due to the Depression, the Second World War provided the bump that was needed to temporarily rejuvenate Seattle's industrial sector. With their men off at war, women took to the factories, carrying out jobs that had been previously male dominated. (Courtesy MOHAI, 14870.5.)

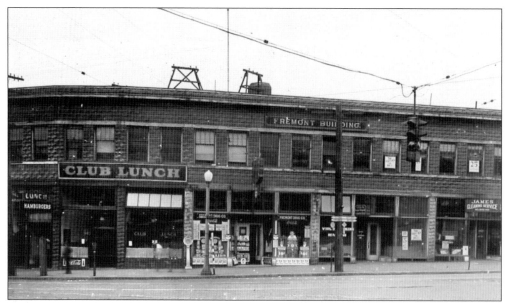

THE FREMONT BUILDING. In addition to Fremont's industrial sector, churches, and schools, local commerce has also been an essential participant in creating the neighborhood's sense of community. The Fremont Building, once home to the Fremont Hotel run by Florence Smith (see page 52), has been a fixture in the neighborhood's downtown area since it was constructed in 1911. In February 1979, the building was added to the City of Seattle's list of historic landmarks. (Courtesy Puget Sound Regional Archives.)

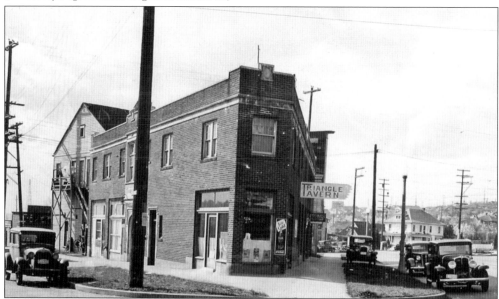

THE TRIANGLE TAVERN, C. 1937. While Fremont's streets are now lined with a multitude of taverns and bars, this was not always the case. In fact, during the early part of the 20th century, bars and taverns were prohibited from opening in Fremont's boundaries because of the neighborhood's inclusion within the two-mile "dry" radius of the University of Washington. Built in 1926, the Thompson Building, pictured here, continues to house the Triangle Tavern today, just as it did 70 years ago. (Courtesy Puget Sound Regional Archives.)

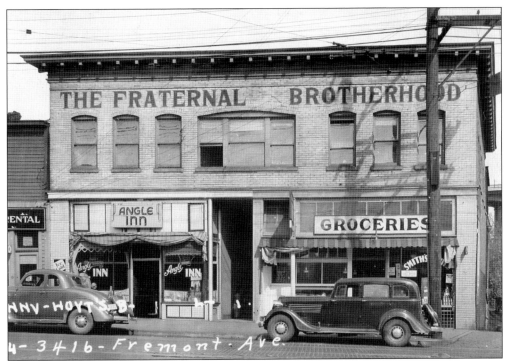

3416 FREMONT AVENUE, C. 1937. Before this building functioned as Smith's Grocery (1934–1943), it housed an number of businesses, including the Romberg and Dixon Bank (1906–1907), Fremont State Bank (1908–1916), the Fremont Theater (1912–1914), and the Fraternal Brotherhood (1923–1933). Now home to the local music store Sonic Boom, one can still find the small chamber in the basement, marked by extra-thick walls, where the bank's safe was once kept. (Courtesy Puget Sound Regional Archives.)

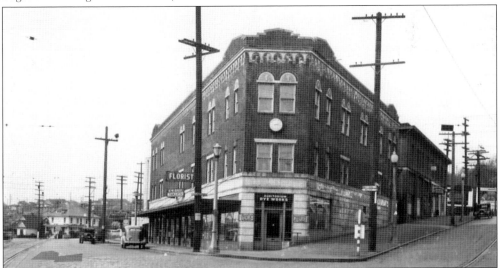

INTERNATIONAL ORDER OF ODD FELLOWS HALL. Built in 1927, this structure has also been the home of a number of businesses over the years and served as the address for Fremont's chapter of the International Order of Odd Fellows, a charitable fraternity that dates back to 17th-century England.

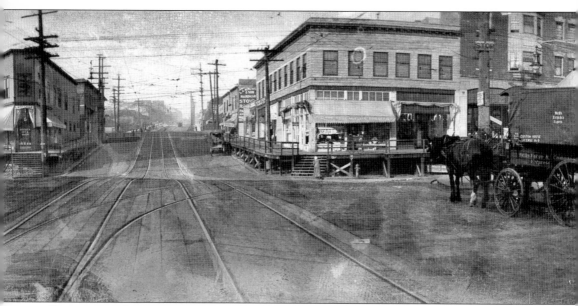

REGRADING FREMONT'S SLOPE. Unknown to many is that Fremont's street levels were once considerably lower and steeper than they are today. During the years 1902–1909, Fremont's downtown was literally raised up and regraded in order to meet the level of the new bridge that was to be built over the Lake Washington Ship Canal. Compare this image to the photographs on the opposite page to see the dramatic alteration that one of Fremont's busiest intersections underwent during the early 1900s. (Courtesy MOHAI, 86.5.9181.2.)

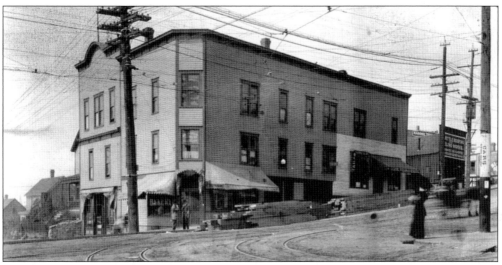

BAKERY, CORNER OF FREMONT AVENUE AND NORTH THIRTY-FIFTH STREET. From 1902 to 1909, Fremont's downtown streets were regraded to a much higher level. Compare the street level in this photograph with that on the opposite page. In 1927, this building was replaced by the IOOF building (see page 83). (Courtesy University of Washington Libraries, Special Collections, Lee 390.)

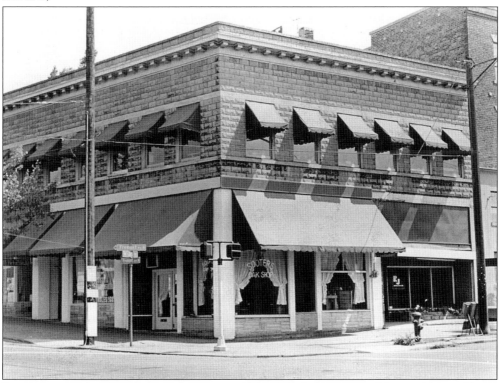

BUILDING AT THE NORTHEAST CORNER OF FREMONT AVENUE AND NORTH THIRTY-FIFTH STREET, 1970S. Like the picture above, this photograph demonstrates the effect that regrading had on Fremont's downtown street level, when compared to the image on the opposite page. (Courtesy University of Washington Libraries, Special Collections, Hamilton, 3715.)

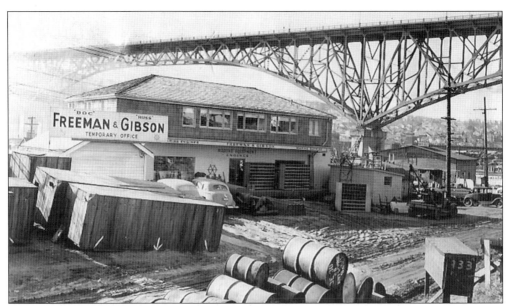

FREEMAN AND GIBSON BENEATH THE GEORGE WASHINGTON MEMORIAL BRIDGE, 1947. In 1928, Orrin "Doc" Freeman purchased the Fremont Boat Market, a 12-year-old boat- and marine-supply business located on the northern shores of Lake Union, from Captain Webster. Built in 1947, the Freeman and Gibson store, pictured here, was eventually known as the Doc Freeman Store and became one of Fremont's most reliable and long-lived, family-owned businesses. (Courtesy Mark Freeman.)

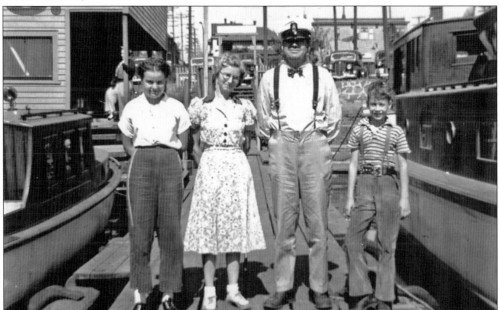

THE FREEMAN FAMILY, 1941. Somewhat of a local celebrity, Doc, who earned this nickname while working as a teamster on Seattle's docks in 1919, sold his marine supply business to two trusted employees in 1952. Here Doc is pictured with his wife, May Fitzpatrick, daughter Merry Freeman (named so because she was born on Christmas day), and son Mark. (Courtesy Mark Freeman.)

MARK FREEMAN, 1941. Although his father sold one of the family businesses in 1952, Mark returned home to Fremont in 1959 after four years in the Coast Guard and bought out the lease on the Fremont Boat Company. A decorated Coast Guard and local hero, Mark now runs Fremont Boat Company, along with several other businesses from the same Fremont land and waters where he spent his childhood. He is among the most well-known and well-respected members Seattle's maritime community and the Fremont neighborhood. (Courtesy Mark Freeman.)

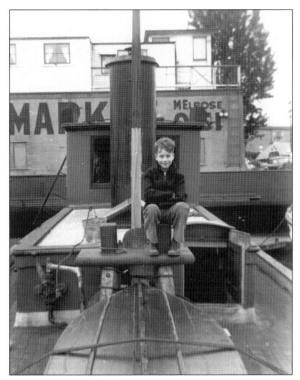

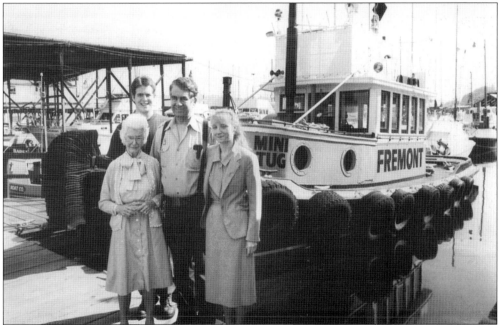

THREE GENERATIONS OF THE FREEMAN FAMILY, 1988. Mark Freeman stands with his wife, Margie; mother, May; and son Erik at the Fremont Boat Company. In keeping with his father's and grandfather's dedication to Seattle's waters, Erik now owns Fremont Tugboat, a successful marine towing business run out of the same office as his father's Fremont Boat Company. (Courtesy Mark Freeman.)

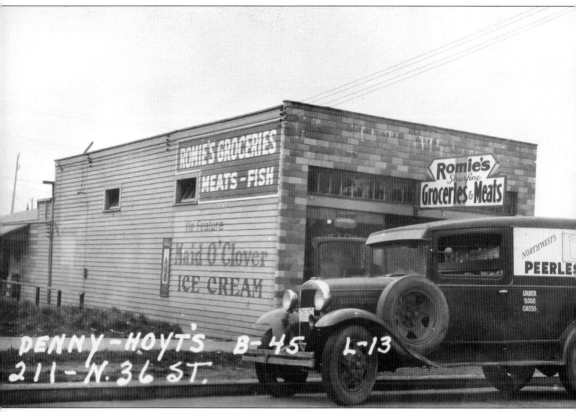

ROMIE'S GROCERY. Romie's Grocery, like many of the retail shops in Fremont, was a family-owned and family-operated business. Helen Johnson Pheasant, wife of Robert Pheasant (see page 42), worked at Romie's as a teenager, taking orders, and fondly remembers the sawdust scattered on the floor beneath the meat counter. She recalls that "Fremont wasn't a place for a young girl," for by the 1930s, Fremont was already beginning to decline as a result of the completion of the George Washington Memorial Bridge that carried traffic away from Fremont's downtown, as well as the Great Depression and the closing of the Brant Lumber Mill, with subsequent loss of local jobs. By the 1950s, Fremont had lost its banks, its post office, and a large collection of other businesses that had once fueled its economy.

Three

FREMONT'S REVIVAL
THE BIRTH OF AN IMAGINATION

For some, the idea that Fremont has experienced a "revival" is an odd or perhaps even inaccurate concept. Fremont never died, after all, it was simply different than it is today. This is certainly true, for even during its most troubled times, the neighborhood maintained a relatively dense residential population, and while its commerce may not have boomed, it was far from bust. Nonetheless, beginning in the 1940s, Fremont fell into a slow decline that had a substantial negative effect on local commerce, as well as the community. Arriving in Fremont from Portland, Oregon, in 1956, local artist Roger Wheeler has clear memories of "the poor people, the old buildings, the [unemployed] men hanging out of windows smoking cigarettes." Not until the 1970s was the Fremont of today forged from the imagination, dedication, and hard work of a diverse collection of creative individuals—including Wheeler—who believed in making the place where they lived a truly vibrant community.

In 1994, after two decades of successful community projects, and in an effort to set itself apart from the rest of Seattle's urban villages, Fremont declared itself the "Center of the Universe." Assuming *de libertus quirkas*, "the freedom to be strange," as its motto, the neighborhood defined itself as an independent republic—the Artist's Republic of Fremont (ARF), characterized as a "state" of mind, or an ImagiNation. Today many of the masterminds behind Fremont's artistic revival of the 1970s and 1980s lament the area's recent gentrification and development. Their legacy, however, is as strong as ever, made evident by Fremont's continued appeal to both quirky and creative minds.

LOOKING NORTH ON FREMONT AVENUE. By the late 1950s, J. R. Burke had closed his mill and turned his waterfront property into an industrial park known as the Burke Industrial Center, seen here. Also of note in this photograph is the pale color of the Fremont Bridge, left. In August 1972, at the request of the Fremont Improvement Company, the Fremont Bridge was painted bright orange—a color that locals felt best reflected their sense of mind. It remained this unusual color until 1984, when, in flurry of controversy, the city repainted the bridge blue, compromising with local residents for orange trim. (Courtesy University of Washington Libraries, Special Collections, Hamilton 1–29.)

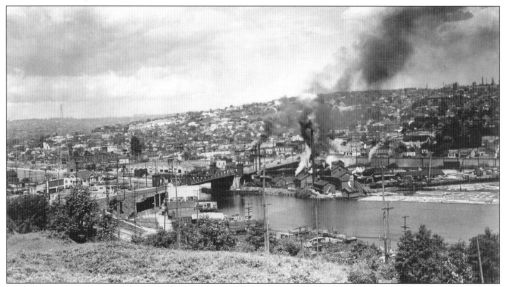

FREMONT, 1930. Compared with the image above, this photograph reveals the extent to which Fremont changed in just four decades. The smoke that once billowed out of the Bryant Lumber Mill each day is long forgotten among today's Fremont residents. (Courtesy MOHAI, 2002.30.9.)

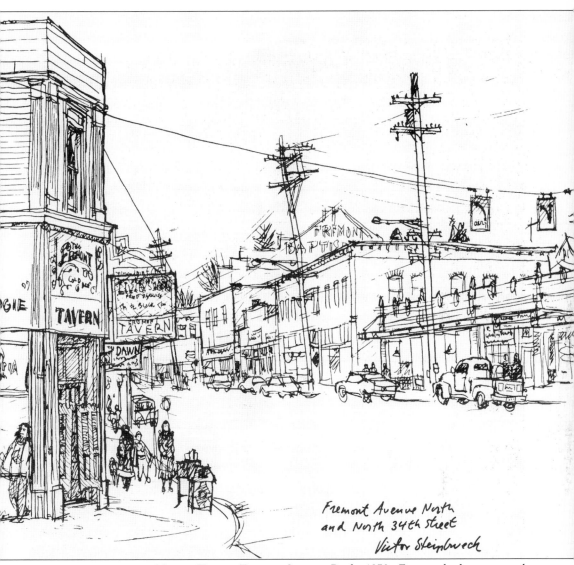

Fremont Avenue North
and North 34th street
Victor Steinbrueck

FREMONT AVENUE AND NORTH THIRTY-FOURTH STREET. By the 1970s, Fremont had experienced considerable change, growth, and decline, but some features of the neighborhood, notably the Fremont Tavern, remained a familiar constant. This drawing by prominent historic preservation advocate Victor Steinbrueck illustrates one of Fremont's major intersections as it would have appeared during the first decade of the neighborhood's "revival." (Courtesy Historic Seattle.)

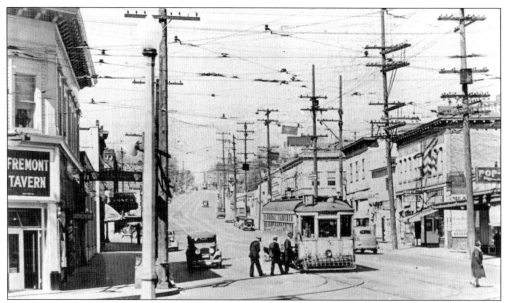

FREMONT AVENUE AND NORTH THIRTY-FOURTH STREET, 1930S. The Fremont Tavern, located at the northwest corner of Fremont Avenue and North Thirty-fourth Street, was among the neighborhood's most long-lived local businesses. Occupying Fremont's oldest existing structure, the Fremont Tavern was once home to the Fremont Drug Company (see cover image), Fremont's first public reading room (see page 80), and is now known as the Red Door (see page 119). (Courtesy University of Washington Libraries, Special Collections, Hamilton 3948.)

CLASSIC TAVERN, 1980S. By the 1970s, taverns made up a large portion of the businesses that lined Fremont's downtown streets, a fact that seems somewhat ironic considering that Fremont had once been included within the two mile "dry" zone that surrounded the University if Washington. To some, this large ratio of taverns was partly responsible for the disagreeable atmosphere that characterized the neighborhood from the 1940s onward. The Classic Tavern, now the Triangle Tavern, occupied the Thompson Building, built in 1926 (see page 83). (Courtesy Fremont Public Association.)

SAFEWAY, NORTH THIRTY-SIXTH STREET. As the Fremont neighborhood began to decline in the 1940s, many of its businesses closed or relocated. Safeway was just one of the businesses that could no longer afford to remain in the area, in part, according to the memory of some Fremont residents, because of locals who sought to "liberate" food from its shelves. (Courtesy Puget Sound Regional Archives.)

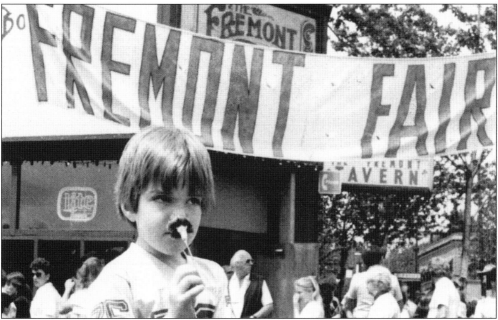

THE FREMONT FAIR. In response to Fremont's deteriorating community and struggling commerce, Frank Chopp helped found the Fremont Public Association in 1974, an organization that aimed to alleviate local poverty, hunger, and unemployment. One of the first events that the FPA sponsored in order to raise money for their programs was the Fremont Fair, a summertime festival that today attracts tens of thousands of people from all over the state. (Courtesy Fremont Public Association.)

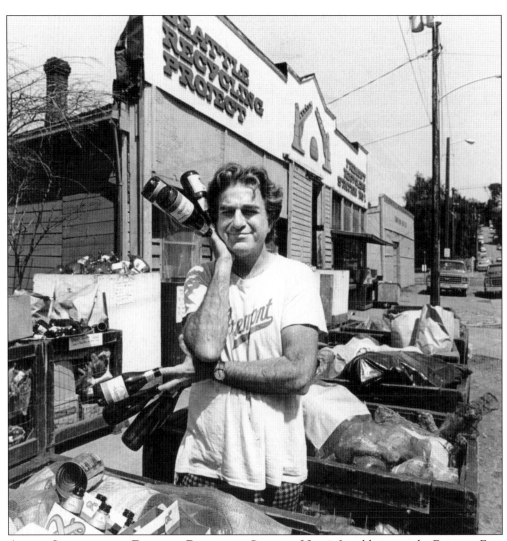

ARMEN STEPANIAN AT FREMONT RECYCLING STATION NO. 1. In addition to the Fremont Fair, the Fremont Public Association also created the nation's first curb-collected recycling program in 1974, lead by Armen Stepanian. The son of Armenian refugees, Armen was raised in New York City and arrived in Seattle in 1970. He quickly became one of neighborhood's biggest personalities and advocates, declaring himself Fremont's honorary "mayor" after a controversial election that some claim was actually won by a black Labrador! Pictured here demonstrating "global warming in a bottle," Armen went on to help establish the Washington State Recycling Association in 1976 and the National Recycling Commission in 1980. It was due to Armen's vision and dedication that Fremont became know as the "district that recycles itself." (Courtesy Fremont Public Association.)

FOODBANK VOLUNTEERS. Another significant program run by the FPA was Fremont's food bank. Staffed entirely by volunteers, the food bank was located just off Fremont Avenue. (Courtesy Fremont Public Association.)

LINE AT THE FREMONT FOOD BANK. Seattle residents wait in line at the food bank run by the Fremont Public Association. The chalkboard to the right of the photograph clarifies which zip codes the food bank served, stressing the FPA's focus on the local community. (Courtesy Fremont Public Association.)

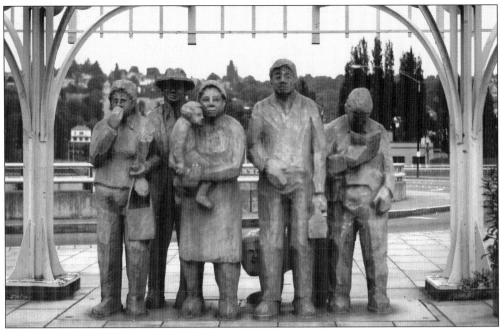

WAITING FOR THE INTERURBAN. In addition to its charitable programs, the FPA was also devoted to promoting Fremont as a pleasant place to live. With the help of the Fremont Arts Council, an offshoot of the FPA, this statue was installed at the same spot where the interurban train once stopped to pickup and drop-off Fremont passengers. Designed by local artist Richard Beyer, *Waiting for the Interurban* was the first of many public art pieces that now ornament Fremont's streets and parks. (Courtesy Fremont Public Association.)

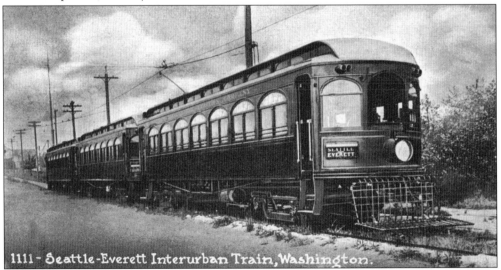

1111 - Seattle-Everett Interurban Train, Washington.

THE INTERURBAN. Among the many forms of transport that connected Fremont to the rest of the city and its surrounding regions was the famous interurban train, which joined Seattle with Everett and Tacoma. Dating back to 1899, intercity travel via train was eventually replaced by buses and personal vehicles. Today Fremont's link to the interurban train service is commemorated by Richard Beyer's life-size sculpture, *Waiting for the Interurban*. (Courtesy University of Washington Libraries, Special Collections, UW26017.)

FREMONT STATION, 1974. Once a stop along the Seattle–Everett interurban line, this station still stands on the southwest corner of Stone Way and North Thirty-fourth, along what is now the Burke-Gilman Trail. (Courtesy University of Washington Libraries, Special Collections, Hamilton 357.)

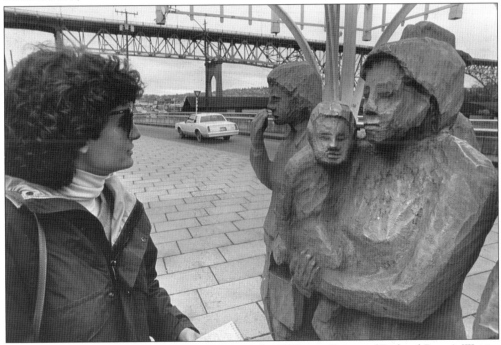

WAITING FOR THE INTERURBAN. In many ways, the 1979 installation of Richard Beyer's *Waiting for the Interurban* at the intersection of Fremont Avenue and North Thirty-fourth Street marked a turning point in Fremont's recent history. A physical testament to the fact that Fremont was a culturally rich community, the statue invited passersby to stop and contemplate the often overlooked history of the neighborhood now capturing so much public attention. (Photograph by Cary Tolman; courtesy MOHAI, Seattle PI- 25475.)

VIEW OF FREMONT CANAL FROM FREMONT CANAL PARK. As the FPA worked to overcome poverty and reintroduce a sense of community to Fremont, the neighborhood's residents were inspired to transform the district's industrially dominated landscape into a more livable space. With the help of Frank Chopp, Ed Strickland, and J. R. Burke, a park along the northern shore of Fremont's canal was proposed and accepted by the city. On June 15, 1981, the canal park was formally dedicated. (Courtesy John Cornicello.)

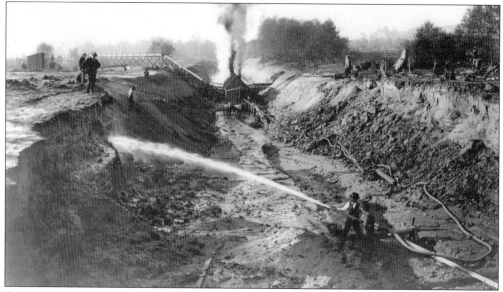

CUTTING THE CANAL AT FREMONT. Bicyclists and pedestrians who now enjoy the serenity of Fremont's Canal Park might find it hard to imagine that, less than a century ago, this same land was the noisy site of one of Seattle's most significant engineering endeavors. (Courtesy University of Washington Libraries, Special Collections, A. Curtis 0078.7)

OUTLOOK OVER THE FREMONT CANAL. In addition to cultivating the landscaping, which had originally been designed by the Seattle Garden Club back in the 1960s, those who designed the Fremont Canal Park were also sure to incorporate spaces, like this deck over the water, which enabled locals to sit and enjoy a sunny day with friends. (Courtesy author.)

ROSS CREEK, 1875. Created by Paul Lewing, this mural at Fremont's Canal Park is an interpretation of what Fremont would have looked like when the Lake Washington Ship Canal was only a narrow creek. In keeping with Fremont's dedication to public art, the budget for the Fremont Canal Park reserved a portion of funds for the creation of new public art, including this mural and two bronze installations by local artist Anita Fisk. (Courtesy author.)

FREMONT'S ROCKET. In 1991, the Fremont Business Association purchased this cold war–era rocket from a surplus store in Seattle's Belltown District for $750. After being spruced up and marked with Fremont's motto, *de libertus quirkas* ("the freedom to be strange"), the rocket was erected on June 3, 1994, and stands today as one of Fremont's most recognizable features. (Courtesy John Cornicello.)

RENOVATING FREMONT'S MURAL AT THE AURORA BRIDGE. Welcoming drivers into Fremont from the George Washington Memorial (Aurora) Bridge, this colorful mural was proposed in 1996 by Fremont Arts Council member Patrick Gabriel and completed in 1997. Initially a branch of the Fremont Public Association (see pages 93–95), the Fremont Arts Council has been one of Fremont's most active groups since its conception in the 1970s. Here a volunteer touches up the murals faded colors. (Courtesy Michelle Bates.)

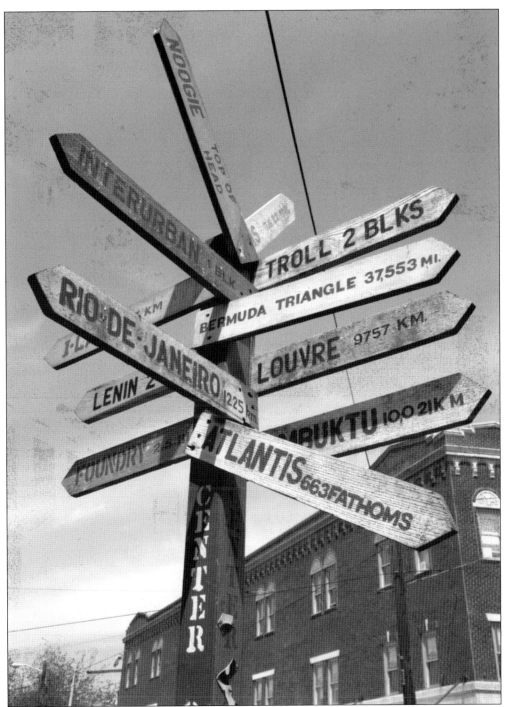

ROAD SIGN, INTERSECTION OF FREMONT AVENUE AND NORTH THIRTY-FIFTH STREET. Marking one of Fremont's major intersections, this tongue-in-cheek road sign captures the playfulness and humor that the Fremont Art Council has injected into the community since its earliest days. Using "creativity to build a stronger community," the Fremont Arts Council has contributed to the aesthetic and social appeal of Fremont for over 20 years. (Courtesy John Cornicello.)

Peter Bevis. An instrumental member of the Fremont Arts Council, Peter Bevis arrived in Fremont for the first time in 1979, just in time to watch the installation of Richard Beyer's sculpture *Waiting for the Interurban*. Inspired by the public art he witnessed in the Fremont community, Bevis, a metal sculpturer born in Eastern Washington, decided to make the neighborhood his home. Since that time, he has been the mastermind behind a number of creative projects, including Fremont's acquisition of Emil Venkov's statue of Vladimir Lenin (see pages 104 and 106) and the Fremont Foundry (opposite page). (Courtesy Muir Public Relations.)

KALAKALA UNDER THE FREMONT BRIDGE, 1999. One of Peter Bevis's most ambitious projects was the attempted restoration of the *Kalakala*, a famous commuter ferry that had served Seattle starting in 1935 until 1967. Used as a fish-processing plant in Alaska for just over 31 years, the *Kalakala* returned to Seattle in 1998 after Bevis was able to arrange for its purchase. Despite Bevis's unwavering dedication and the ferry's popularity among locals, complications forced Bevis to abandon the project in 2003. (Courtesy Muir Public Relations.)

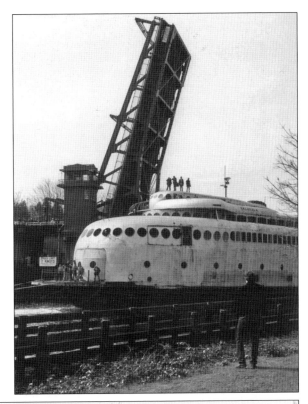

THE FOUNDRY. Another one of Bevis's projects that has significantly marked the Fremont community is the Foundry. Designed as an affordable work-live space for local artists, Bevis built the foundry on four lots of land previously occupied by dilapidated houses. (Courtesy author.)

THE LENIN STATUE FOR SALE AT THE FREMONT SUNDAY MARKET. Like Fremont's rocket (see page 100), this statue of Vladimir Lenin is one of the defining landmarks of Fremont's urban landscape. Brought to Fremont at the urging of local artist Peter Bevis, this statue cost over $40,000 to transport to the United States from Slovakia and is pictured here for sale at the Fremont Sunday Market. For more on this piece of public art, see page 106. (Photograph provided by John Hegeman; courtesy of Muir Public Relations.)

FREMONT SUNDAY MARKET. Founded in 1990 by Jon and Candace Hegeman and Marcia Hunt, the Fremont Sunday Market is among the neighborhood's most enjoyed public events. Crowds gather to browse and purchase delights promised by the market on a sunny summer day. (Courtesy John Cornicello.)

FREMONT SUNDAY MARKET. Held every week year round, Fremont's outdoor Sunday market caters to both the flea market junky and the scrutinizing antique connoisseur. Whether a shopper is searching for vintage chairs or an unusual piece of jewelry, they are likely to find what the looking for here—rain or shine. (Courtesy John Cornicello.)

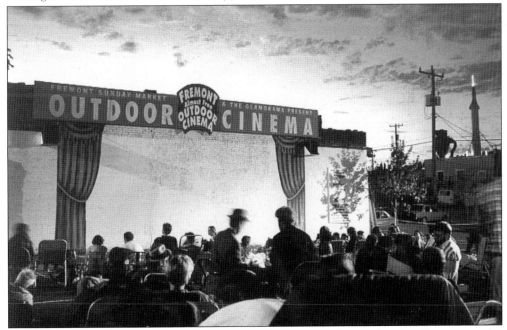

FREMONT OUTDOOR MOVIES. In addition to the Fremont Sunday Market, Jon Hegeman is also responsible for establishing Fremont's outdoor cinema in 1991. Showing an eclectic mix of movies after sundown, the Outdoor Cinema has become a popular and inexpensive way to spend Saturday nights during the warmest months of the year. (Courtesy Muir Public Relations.)

FREMONT'S LENIN STATUE. Acquired by Lewis Carpenter while he was teaching in Poprad, Slovakia, at the fall of the Iron Curtain, this statue of communist leader Vladimir Lenin came to Fremont in 1995 in the face of tragedy. Having spent over $40,000 to purchase and transport the statue from Slovakia to the United States, Carpenter was killed in car crash in 1994, leaving Lenin dismantled at his Washington home. Upon hearing of Carpenter's unexpected death and the circumstances surrounding the statue's arrival in the United States, Peter Bevis stepped into help Carpenter's family, offering to consign the statue for sale in Fremont. Now a neighborhood icon, Lenin remains for sale to this day, although it is hard to imagine Fremont without this unusual and politically charged piece of art looming over pedestrians. (Courtesy author.)

MAY DAY. In addition to Fremont's visible markers, like Lenin or the rocket, the community is also characterized by a number of seasonal events that provide neighbors with an opportunity to come together and celebrate the passing of time. Along with the annual winter solstice feast, summer solstice parade, and "Trolloween," the Fremont Arts Council arranges a May Day celebration, pictured here, which welcomes the change in seasons. (Courtesy John Cornicello.)

THE FREMONT TROLL. Perhaps the most popular of all of Fremont's landmarks, the troll rests beneath the George Washington Memorial Bridge clutching a Volkswagon Bug. Created by a group of artists collectively known as "Jersey Devils" (Steve Badanes, Donna Walter, Ross Whitehead, and Will Martin), Fremont's troll is another impressive project initiated by the Fremont's Arts Council, under the leadership of Barbara Luecke. Each October, residents gather at the troll to celebrate Trolloween, with song and dance. (Permission for use of this image was provided by the Fremont Arts Council, photograph courtesy Seattle Municipal Archives.)

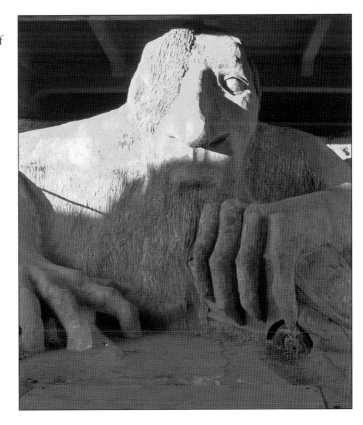

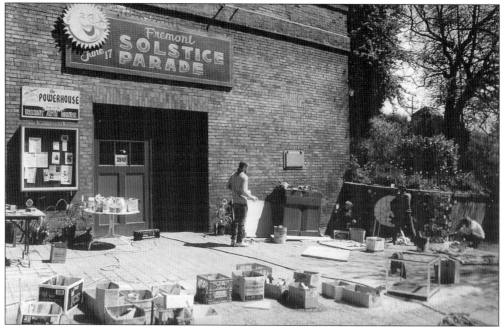

THE POWERHOUSE AT B. F. DAY SCHOOL. Constructed in 1916 to serve as a boiler plant for B. F. Day Elementary School, the Powerhouse is now the home of the Fremont Arts Council, which uses the facility to create the elaborate floats and puppets that take to the streets of Fremont each year for the annual Solstice Parade. (Courtesy Michelle Bates.)

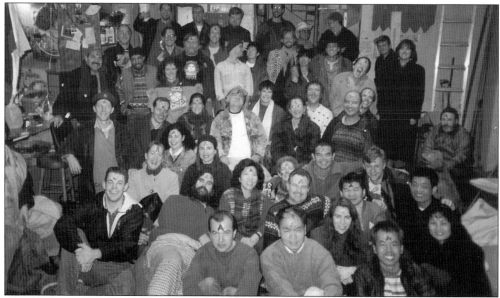

MEMBERS OF THE FREMONT ARTS COUNCIL GATHER AT THE POWERHOUSE. Perhaps more than any other group, the Fremont Arts Council, established during the 1970s, has had a powerful, visible impact on the Fremont neighborhood. By sponsoring and producing numerous works of public art, as well as organizing a menagerie of public seasonal festivals, the FAC has transformed Fremont from an industrial suburb of downtown Seattle into a Pacific Northwest destination. (Courtesy Michelle Bates.)

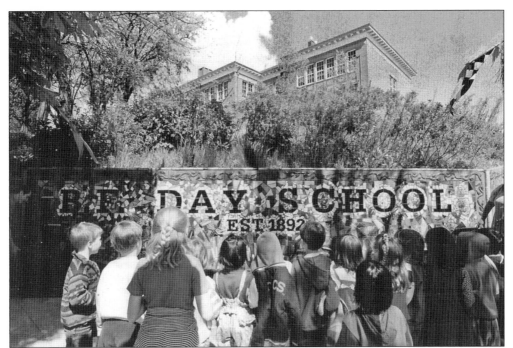

Tile Wall, B. F. Day Elementary School. Organized by the Fremont Arts Council in 1996, these colorful mosaic tiles ornament the concrete retaining wall that surrounds B. F. Day Elementary School. (Courtesy Michelle Bates.)

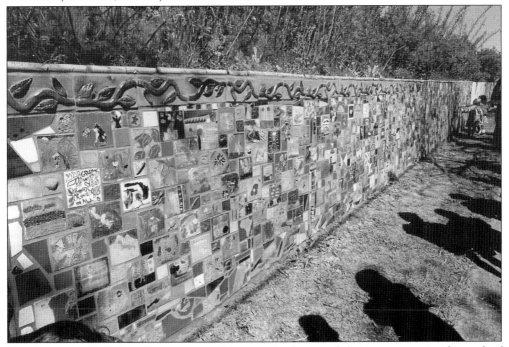

Tile Wall At B. F. Day Elementary School. Students and their parents enjoy the work of local artists Steve Roache and Llyle Morgan (among others), at B. F. Day School's tiled wall on North Thirty-ninth Street. (Courtesy Michelle Bates.)

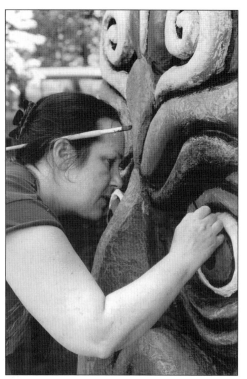

ARTISTS PREPARE FOR THE ANNUAL SOLSTICE PARADE. Attended each year by thousands of spectators, Fremont's Solstice Parade, founded in 1989 by Peter Tomf and Barbara Luecke, is one of Seattle's favorite summertime events. Although organized separately from the Fremont Public Association's annual Fremont Fair, the Solstice Parade is now considered the fair's opening event. Here an artist prepares one of the elaborate puppets featured in the 2001 parade. (Courtesy Michelle Bates.)

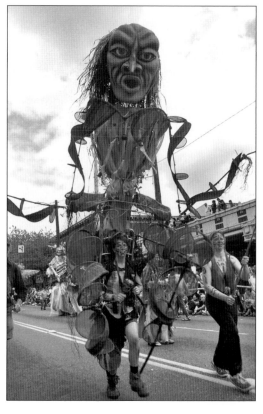

PUPPET AT THE SOLSTICE PARADE. These puppets marching down Fremont Avenue in front of the McKenzie Building have helped to define the Solstice Parade as a spectacle of local craftsmanship and artistry. While not apolitical, the Solstice Parade discourages advertising and encourages creativity by requiring that parade participants stick to four basic rules—no printed words, no live animals, no motor vehicles, and no guns or weapons. (Courtesy Seattle Municipal Archives.)

FLOAT AT THE SOLSTICE PARADE.
Elaborate, colorful, and engaging, the floats featured in the annual Solstice Parade take months to organize and create. (Courtesy Seattle Municipal Archives.)

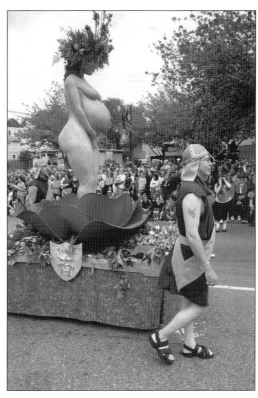

SPECTATORS AT THE SOLSTICE PARADE.
Parade spectators gather in anticipation in front the Ball Room, one of Fremont's popular nightlife spots. In recent years, the Solstice Parade's popularity has increased almost beyond Fremont's capacity—tens of thousands of people attend the event from all over the state in order to capture a glimpse at the giant animated puppets and naked bicyclists. (Courtesy Seattle Municipal Archives.)

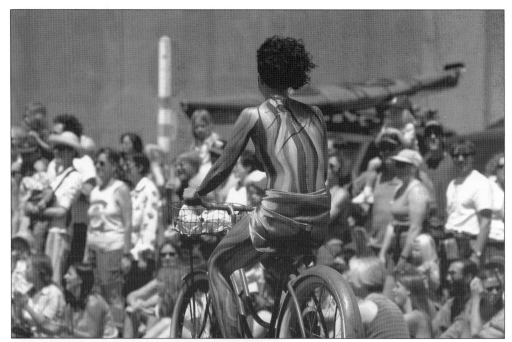

NAKED BICYCLIST AT THE PARADE.
More than the floats, dancers,
musicians, or puppets, it is the
parade's famous naked bicyclists who
receive the most reaction from the
crowd. While this Solstice Parade
tradition began with just a handful of
nude bikers in the early 1990s, close
to 100 individuals now volunteer
to pedal through Fremont wearing
nothing but body paint. (Courtesy
Seattle Municipal Archives.)

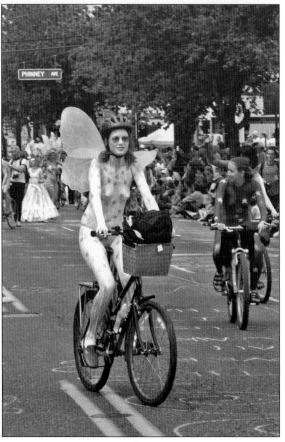

NAKED BICYCLIST AT THE PARADE.
Although nude, this bicyclist makes
a point of observing helmet laws.
(Courtesy John Cornicello.)

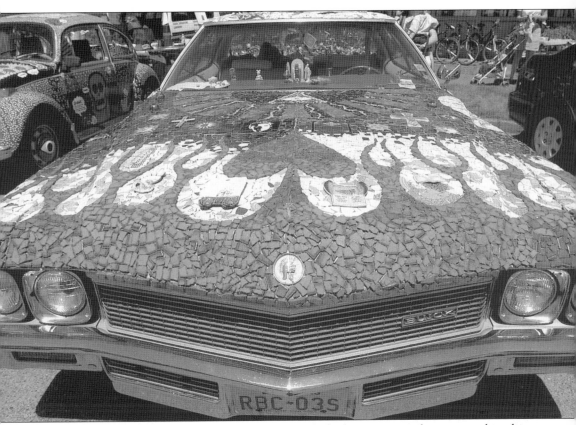

FREMONT FAIR. For those who prefer to remain fully clothed, car art is an alternative to bicycling naked and is on display each year at the Fremont Fair, a two-day event that follows the annual Solstice Parade and is organized by the Fremont Public Association to raise money for charity. (Courtesy Seattle Municipal Archives.)

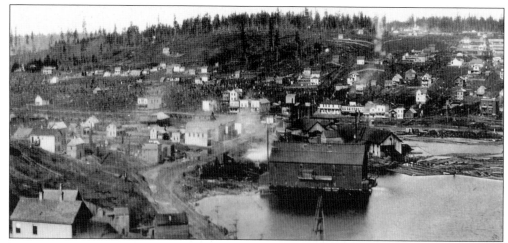

FORESTED FREMONT, 1890S. Just over a century ago, as this photograph shows, Fremont was still covered in thick, primeval forest that made perfect lumber for building Seattle's new houses. Looking carefully, one can spot some of the district's earliest buildings, including a precursor to the Fremont Bridge, the Fremont (later Bryant) Lumber Mill, and the Shorey House, which was home to many of the mill's single male workers. (Courtesy University of Washington Libraries, Special Collections, UW4409.)

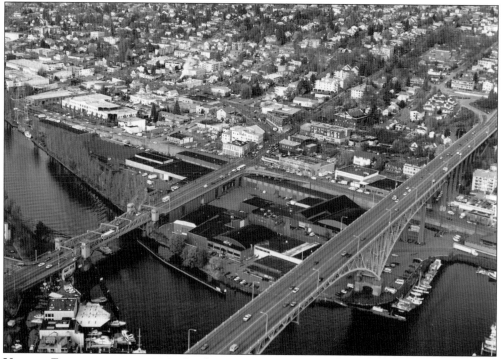

VIEW OF FREMONT IN THE 1980S. By the 1980s, Fremont's lush forests had disappeared, a canal had successfully connected Puget Sound to Lake Union, and both the Fremont and Aurora Bridges were crossed by thousands of cars, trucks, and buses each day. Where the Bryant Lumber Mill had once coughed up black smoke and woodchips, there was now an industrial park—the landownership of which was acquired by one of Fremont's biggest and arguably most controversial personalities, Suzie Burke, from her late father, J. R. Burke (see page 81). (Courtesy Mike Peck.)

ADOBE SYSTEMS INCORPORATED AT THE QUADRANT LAKE UNION SITE. In June 1998, ground was broken on the land once occupied by Fremont's first commercial venture, Isaac Burlingame's Fremont Lumber Mill, to make way for the new era of computer technology. Here the massive Quadrant Lake Union Center, where Adobe Systems Incorporated is now located, yawns upon Fremont's waterfront. Founded in December 1982 by Charles Geschke and John Warnock, Adobe Systems has revolutionized the manner in which computers can be used to create documents and programs. (Courtesy John Cornicello.)

OKTOBERFEST AT THE QUADRANT LAKE UNION CENTER, 2005. Each fall, the Fremont Chamber of Commerce sponsors one of the neighborhood's many seasonable celebrations, Oktoberfest. Here beer lovers enjoy perusing sales booths on a sunny autumn day at the site of the Quadrant Lake Union Center, where Fremont's Oktoberfest is traditionally held. (Courtesy John Cornicello.)

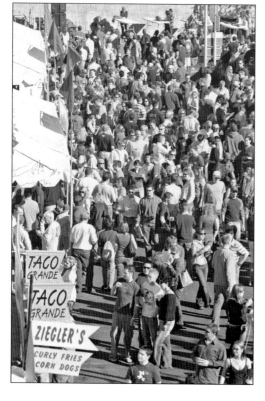

CROWDS AT OKTOBERFEST. Similar to Fremont's other seasonal festivals, such as the Fremont Solstice Parade, Oktoberfest draws people to Fremont from all over the Greater Puget Sound region. (Courtesy John Cornicello.)

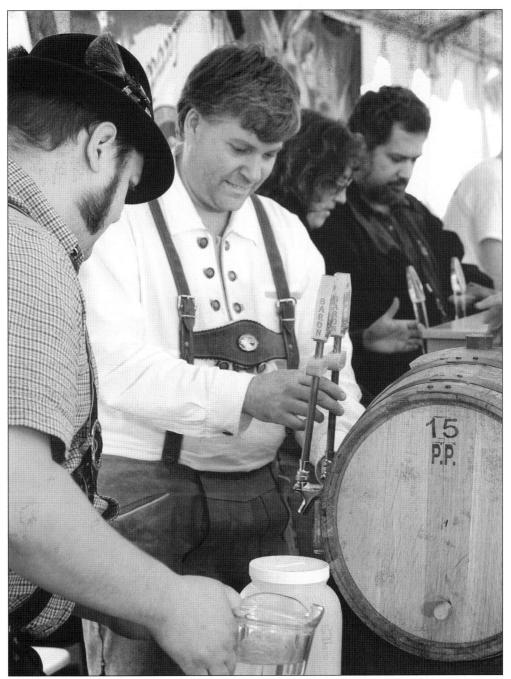

BARON BREWING AT FREMONT'S OKTOBERFEST. Each year, a selection of local microbreweries are invited to participate in Fremont's Oktoberfest and share their ales, lagers, and porters with the public while raising money for the neighborhood. Home to Hale's Brewing Company, and once the address of Red Hook (which was located in the neighborhood's historic carbarn), Fremont has a history of beer appreciation. Here representatives of Baron Brewing, a local Seattle brewing company that specializes in German-style beer, pours a sample of their best. (Courtesy John Cornicello.)

BREAKING GROUND FOR CONSTRUCTION ALONG THE CANAL. At the close of the 20th century, downtown Fremont underwent a number of substantial changes, particularly upon land owned by Suzie Burke, daughter of J. R. Burke of the Burke Mill Company. Having inherited a large portion of Fremont's industrial land from her father, Suzie Burke went on to purchase and develop much of Fremont's industrial properties along its waterfront. In 2000, for example, ground was broken directly west of the Fremont Bridge in order to develop a business park, similar to the Quadrant Lake Union Center, which is occupied today by Getty Images (see page 115). (Courtesy Muir Public Relations.)

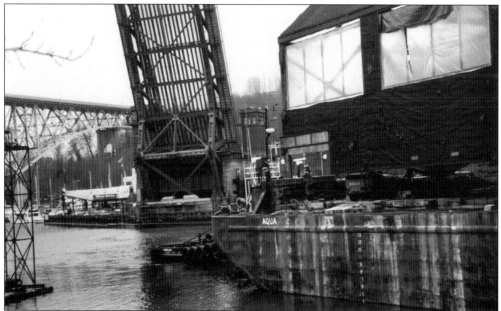

RELOCATING THE TPN BUILDING, 2000. While some buildings were torn down during construction along Fremont's industrial waterfront in 2000, others were moved. Pictured here, a large warehouse, now the office of TPN, is relocated to the other side of the Fremont Bridge, just east of its original location. (Courtesy Muir Public Relations.)

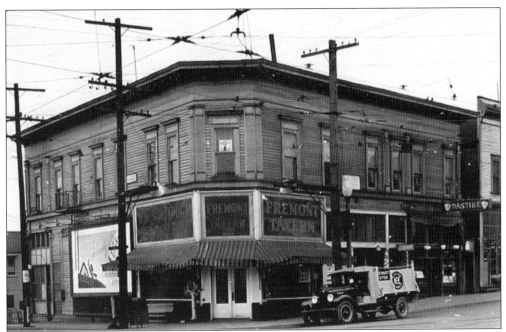

THE FREMONT TAVERN, C. 1937. As Fremont's oldest existing structure, this building has undeniably withstood the tests of time. In the 1890s, a team of oxen moved it from its original location across the would-be canal to its address here at Fremont Avenue and North Thirty-fourth Street. Now home of the Red Door, the building was moved again in 2001, one block west to Evanston Avenue, this time on the wheels of a 747 airplane. (Courtesy Puget Sound Regional Archives.)

RELOCATING THE RED DOOR, 2001. Teetering above street level, the Red Door—formerly the Fremont Tavern and Fremont Drug Company—awaits its final resting place at Evanston and North Thirty-fourth Street. (Courtesy Muir Public Relations.)

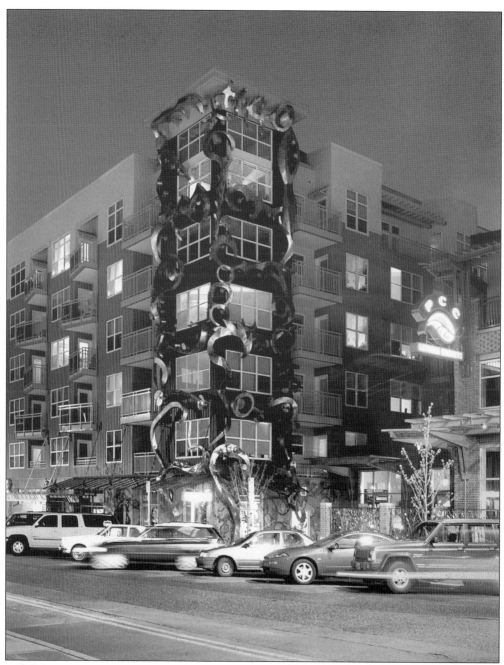

THE EPICENTER. Dominating the entrance to Fremont when traveling north across the Fremont Bridge, the Epicenter, designed by Bumgardner Architecture and developed by Security Properties, was completed in 2003. This huge, multiuse building, which combines retail space with 128 rental units, has been both a source of controversy and delight to Fremont residents since its conception. The massive metal sculpture, *Monsuring* ("jewelry of heaven" in Thai), which curls around the Epicenter's six-story tower was created by artist Mark Stevens and is comprised of twenty-one 400- to 500-pound welded metal pieces. It was just one part of the $250,000 that Security Properties devoted to public art at the request of the neighborhood. (Courtesy Randall J. Corcoran.)

ART INSTALLATION AT THE EPICENTER. Local glass artist Rodman Miller installs glass art on the balconies of the Epicenter. The great-grandson of Louis Comfort Tiffany, Miller did not begin his career in glass art until he had already established himself as professor of anatomy at the University of Calgary. He has created a number of glass sculptures for the Fremont community, including two playful neon-and-glass pieces that adorn the Fremont Bridge. (Courtesy Muir Public Relations.)

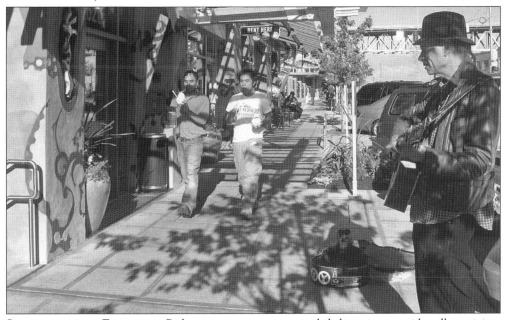

SIDEWALK AT THE EPICENTER. Pedestrians enjoy ice cream while listening to a sidewalk musician, strolling in front of the Epicenter on North Thirty-fourth Street. (Courtesy Dan Hogman of Bumgardner Architects.)

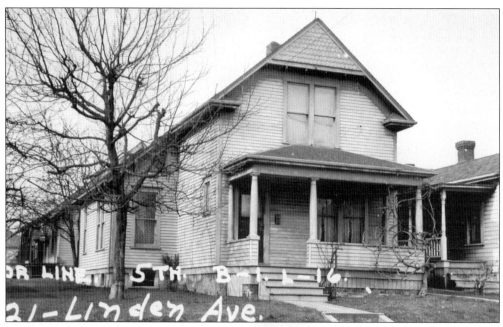

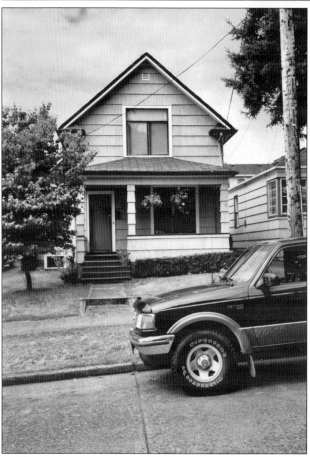

4221 LINDEN AVENUE, C. 1937.
As industrial and commercial buildings have undergone significant alteration and development in the heart of the Fremont district, more modest endeavors have been made uphill to restore Fremont's historic residential buildings. In 1998, Heather McAuliffe and her husband, Shawn Mulanix, purchased this home, built between 1904 and 1905, with the hope of restoring its early 19th-century appeal. The couple used this photograph, found at the Puget Sound Regional Archives, to help piece together what their new home had once looked like. (Courtesy Puget Sound Regional Archives.)

4221 LINDEN AVENUE, 1998.
Scarred with modern, metal-framed windows and cedar shingles that were probably added in the 1940s, McAuliffe and Mulanix's house had lost much of its original charm by the late 1990s. (Courtesy Heather McAuliffe.)

RESTORING 4221 LINDEN AVENUE, 1998. While removing the cedar shingles from the house's outer walls, Mulanix discovers that the original clapboard remains intact. (Courtesy Heather McAuliffe.)

4221 LINDEN AVENUE, 2006. After eight years of remodeling, 4221 Linden Avenue once again resembles its original 1905 state. The renovation of this small house is just one example of how Fremont's residents have remained attentive and inspired by their local heritage. (Courtesy Heather McAuliffe.)

FREMONT PEAK PARK LOGO. Uphill from the neighborhood's busy commercial streets, Fremont boasts some of the city's most spectacular views. From the peak of Fremont's hill, one can see from Mount Rainier and all the way past the Puget Sound to the Olympic Mountains. It was the inspiration drawn from these views that motivated Fremont resident Jack Tomkinson to push the city for a park that would take advantage of Seattle's surrounding natural beauty. His dedication to the project exemplifies Fremont's continual push toward neighborhood improvement through community teamwork. (Courtesy Jack Tomkinson.)

RAISING AWARENESS. Jack Tomkinson and Jill Steinberg raise money and awareness for Fremont Peak Park on the banks of the Lake Washington Ship Canal. By the end of 2000, three lots of land belonging to Tony Murphy had been selected for the park's location. (Courtesy Jack Tomkinson.)

SECURING FUNDS FOR THE PARK. By January 31, 2001, a property deal for the purchase of the land on which the Fremont Peak Park would be built was sealed with the help of a Fremont landowner, Suzie Burke, who put down over $1 million for the project. Pictured here, from left to right, are Donald Harris of the Seattle Parks Department, Suzie Burke, and Jack Tomkinson. (Courtesy Jack Tomkinson.)

FREMONT STREET STAIRCASE. Winding their way uphill towards the Fremont Peak Park, stairways like this one are stitched throughout Fremont's steep landscape, and allow those on a stroll to take shortcuts across the neighborhood's narrow streets. Despite an increase in traffic, the majority of residential Fremont remains quiet and pedestrian friendly. (Courtesy author.)

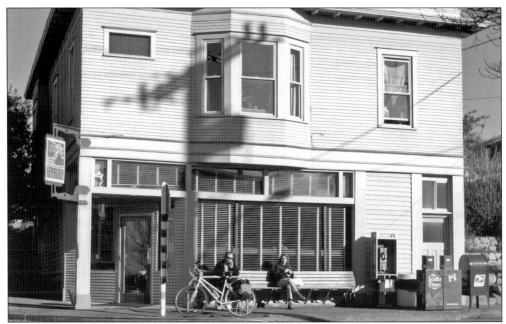

LIGHTHOUSE ROASTERS FINE COFFEES. Once Young's Grocery, locals purchased this building at the northeast corner of North Forty-third Street and Phinney Avenue in 1973 and converted it into a co-op that ran successfully into the 1980s. In 1994, typifying Seattle's world-famous coffee culture, the building was taken over by Lighthouse Roasters, which has provided Fremonters with their daily fix ever since. Fremont is also home to one of Seattle's very first coffee shops, ETG Coffee on North Thirty-sixth Street. (Courtesy author.)

FREMONT'S NEWEST NEIGHBORS. Author Helen Divjak (center) enjoys a pint at her favorite local bar, the George and Dragon, with fellow Fremont residents Kathleen Manley (left) and Jenna Conrad (right). Trained as an artist in St. Paul, Minnesota, Manley relocated to Fremont in 2003. A musician and painter, Conrad came to Fremont in 2002 and has since successfully established herself within Seattle's music scene. Together these ladies exemplify Fremont's continued appeal to young, creative minds. (Courtesy author.)